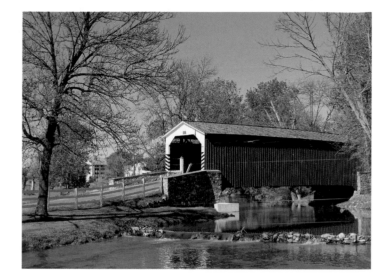

PENNSYLVANIA

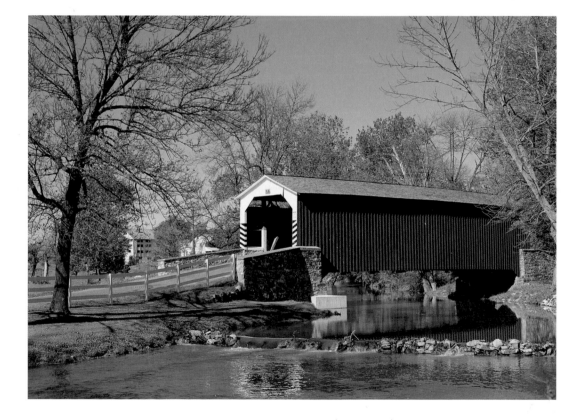

WHITECAP BOOKS
VANCOUVER / TORONTO / NEW YORK

Text by Tanya Lloyd
Edited by Elaine Jones
Photo editing by Tanya Lloyd
Proofread by Lisa Collins
Cover and interior design by Steve Penner
Interior layout by Graham Sheard
Printed and bound in Canada

Canadian Cataloguing in Publication Data

Lloyd, Tanya, 1973–

 Pennsylvania

 (America series)
 ISBN 1-55285-115-X

 1. Pennsylvania—Pictorial works. I. Title. II. Series: Lloyd, Tanya,
1973- America series.
F150.L66 2000 974.8'044'0222 C00-0911068-2

The publisher acknowledges the support of the Canada Council and the Cultural
Services Branch of the Government of British Columbia in making this publication
possible. We acknowledge the financial support of the Government of Canada through
the Book Publishing Industry Development Program for our publishing activities.

**For more information on the America Series and other Whitecap Books
titles, please visit our web site at www.whitecap.ca.**

William Penn must have seemed like a man destined for greatness. Despite an intolerant political climate, the opposition of his family, and a series of arrests, Penn was determined to reform the church and society. He joined the Religious Society of Friends — the Quakers — in the 1660s, and when a Quaker named George Fox suggested a settlement in the New World, Penn seized upon the idea.

By 1681, Penn had convinced King Charles II to grant him a parcel of land in what is now Pennsylvania. To his newborn colony, Penn invited anyone who believed in God. He offered religious freedom, a peaceful land, and laws concerned more with reform than with punishment.

Drawn by this religious freedom and by the abundance of fertile land, immigrants soon arrived in droves. Mennonites, Amish, Quakers, and smaller sects built communities and worked homesteads. The development of industry followed, and coal, iron, and steel was soon flowing out of the region by canal and newly built rail lines.

Today, visitors to Pennsylvania can readily find themselves immersed in this varied history. A tour through Pennsylvania Dutch country reveals traditional farming techniques, horse-drawn buggies, and schoolchildren looking much as students here did a century ago. For many residents of Lancaster County, Penn's vision of a simple and peaceful life still rings true.

In other parts of the state, Gettysburg National Military Park brings the Civil War to life, Steamtown National Historic Site commemorates the time of the steam locomotive, and the Liberty Bell stands as a lasting symbol of independence. And, of course, for those ready to return to the present, the thriving cities of Philadelphia and Pittsburgh offer sights ranging from the works of Andy Warhol to the cultural legacies of Andrew Carnegie.

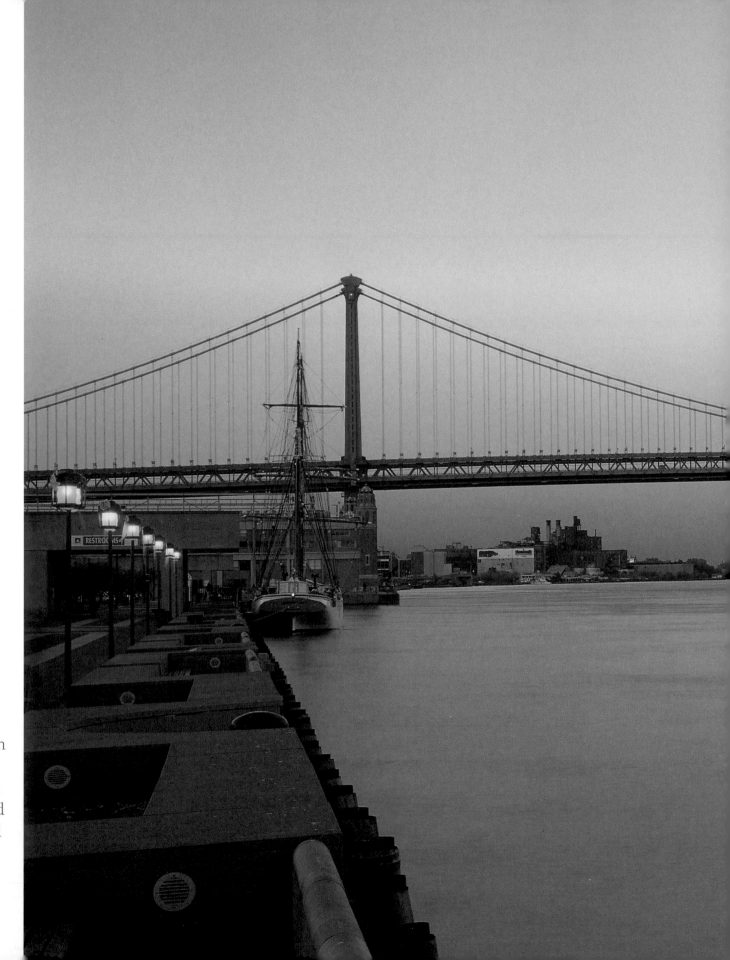

In 1776, when the Declaration of Independence was signed, Philadelphia was the largest city in America. Now home to 1.4 million people, the city takes prides in its fascinating ethnic neighborhoods, active arts organizations, and countless festivals and events.

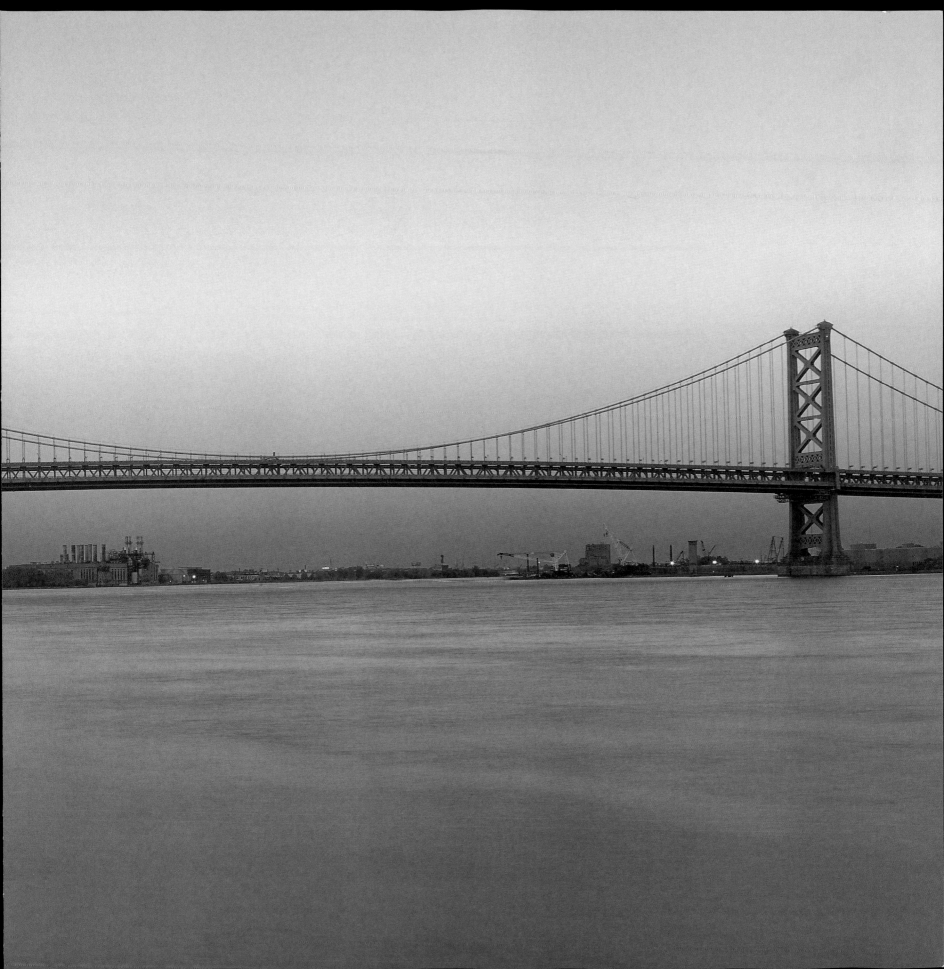

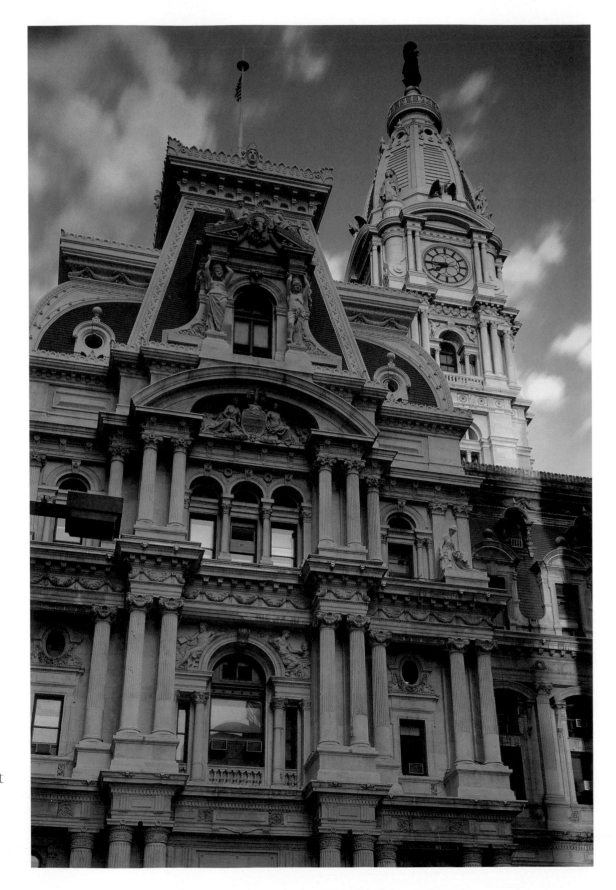

William Penn, founder of Philadelphia, is immortalized in a 37-foot bronze statue at the peak of City Hall. Penn was granted land by King Charles II and, along with surveyor Captain Thomas Holmes, set about creating his vision of a "greene countrie towne."

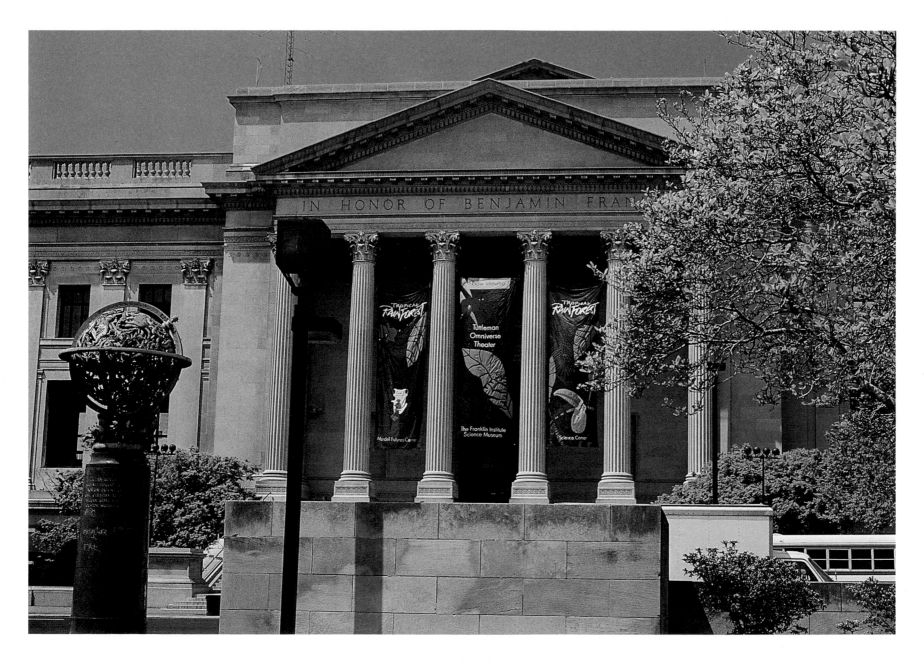

Money to build the Franklin Institute Science Museum was raised in just five days in 1930. The museum honors scientist, inventor, and philosopher Ben Franklin by promoting science exploration and education. The museum attracts 850,000 visitors each year.

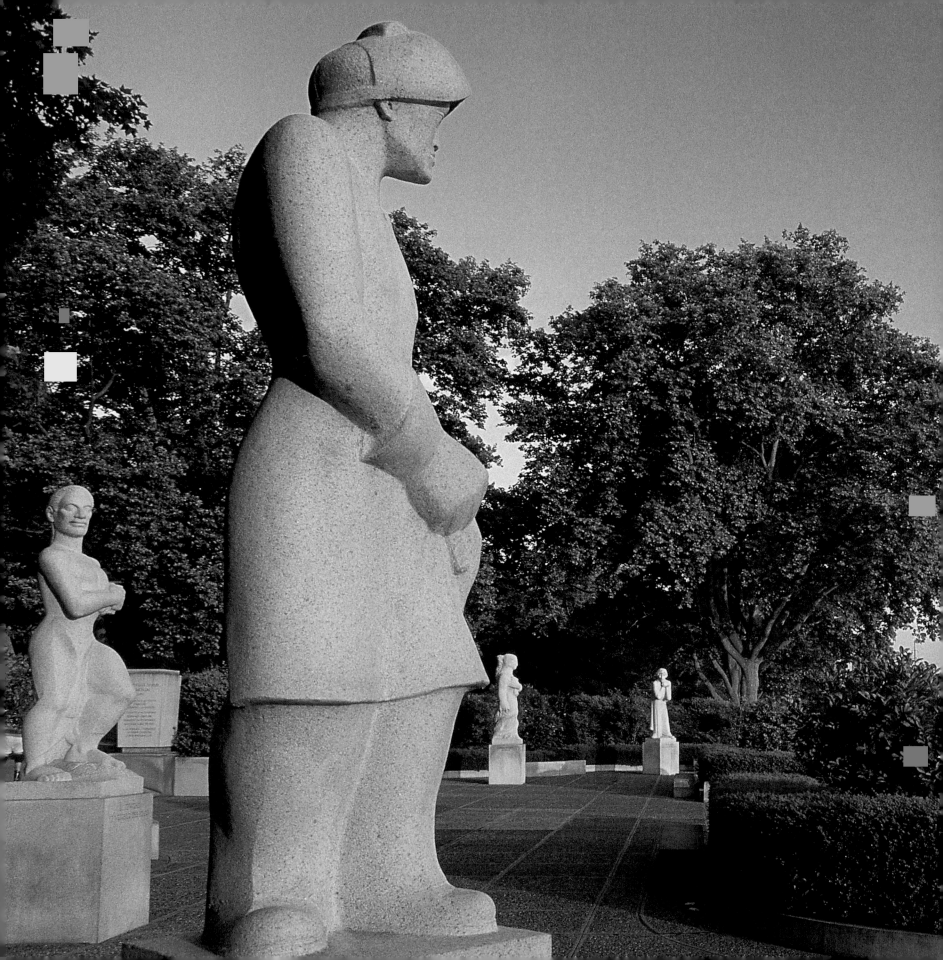

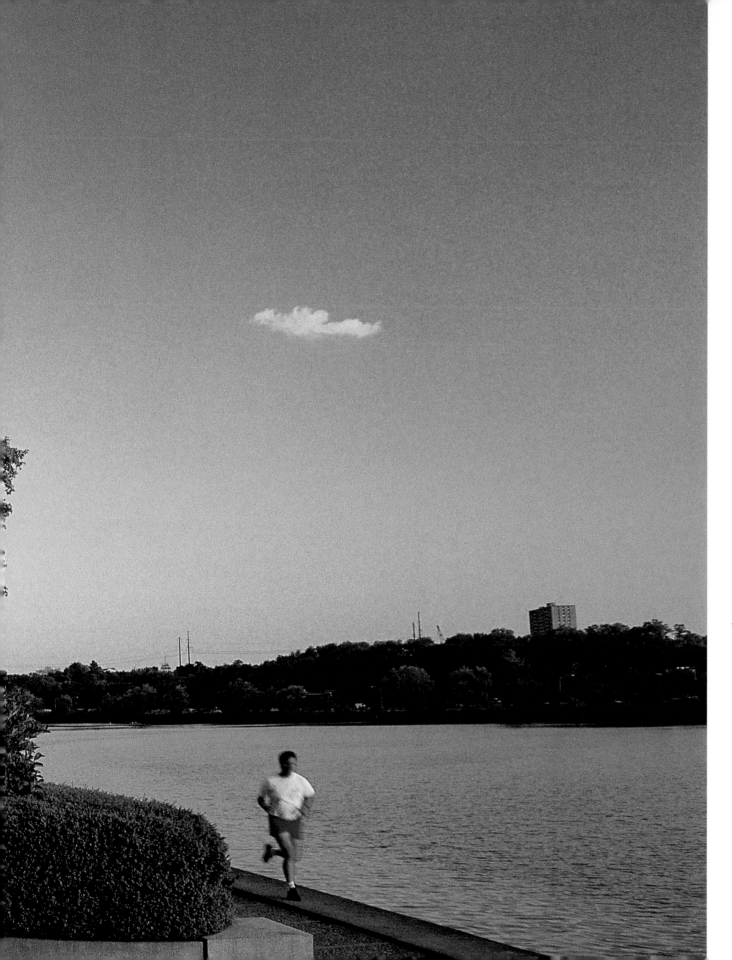

A popular retreat for joggers, strollers, or picnickers, 8,900-acre Fairmont Park is the largest landscaped urban park in the world. From historic sculptures and mansions to sports fields and 100 miles of trails, the park offers something for every visitor.

Elfreth's Alley in Philadelphia's Old City retains its original cobblestones. The oldest house here dates from 1702, making this the oldest continually inhabited street in the nation.

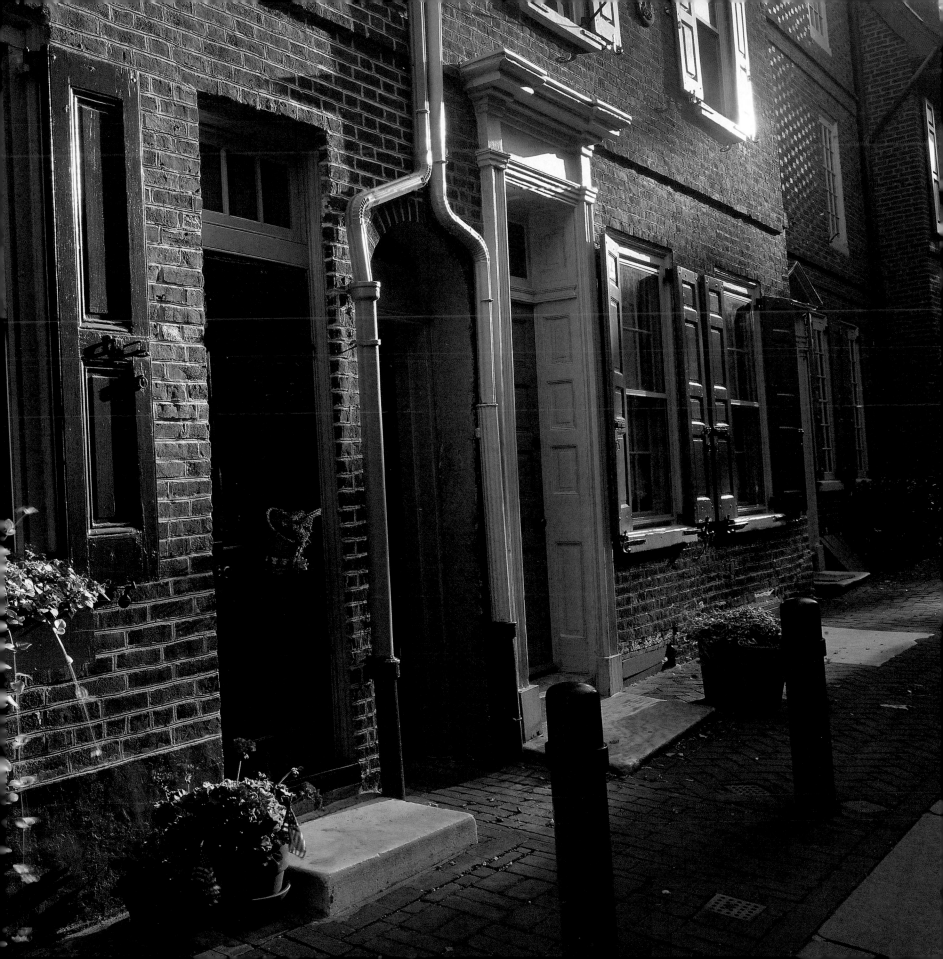

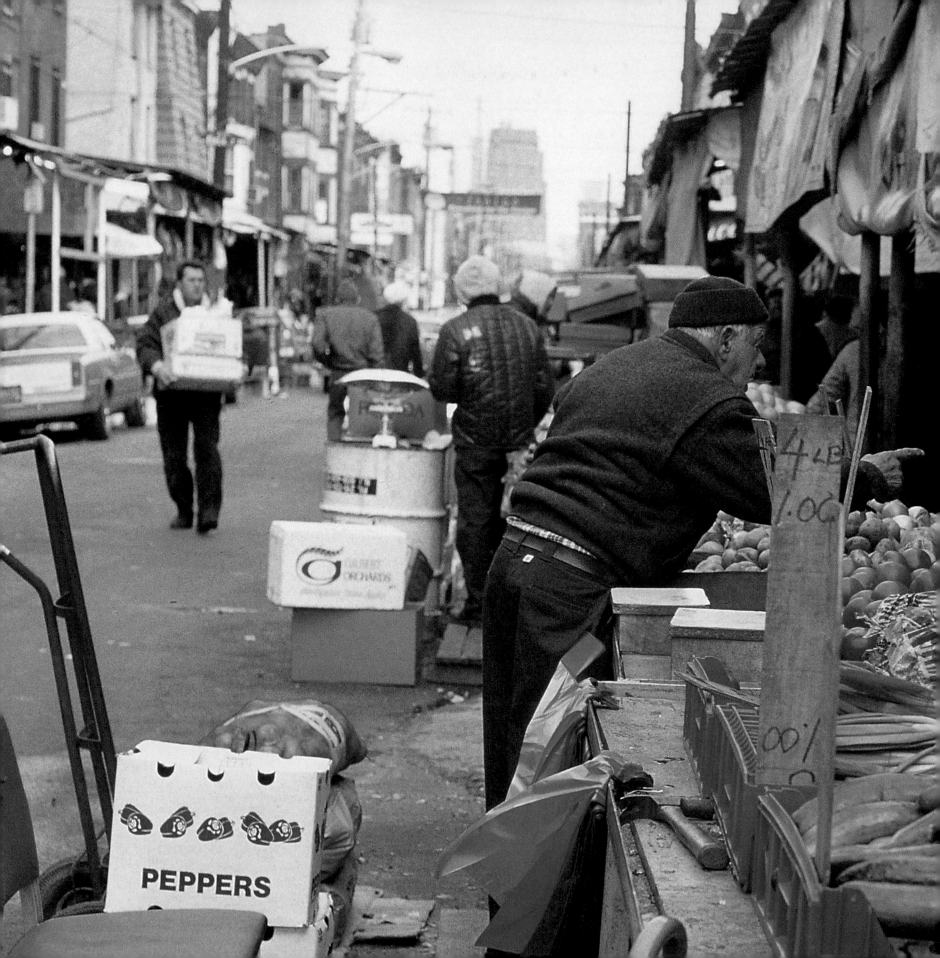

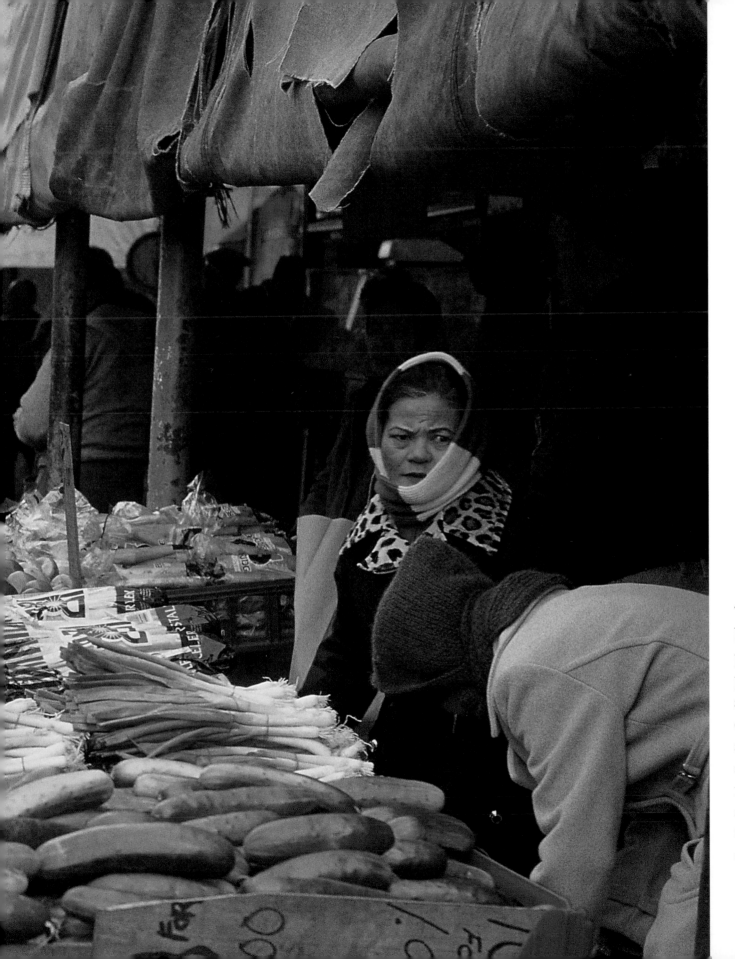

The smell of baking bread fills the air, produce spills from pushcarts, and shoppers sip strong coffee under colorful awnings. Wanderers at the Italian Market may think they've stepped back in time to a European market a century ago.

15

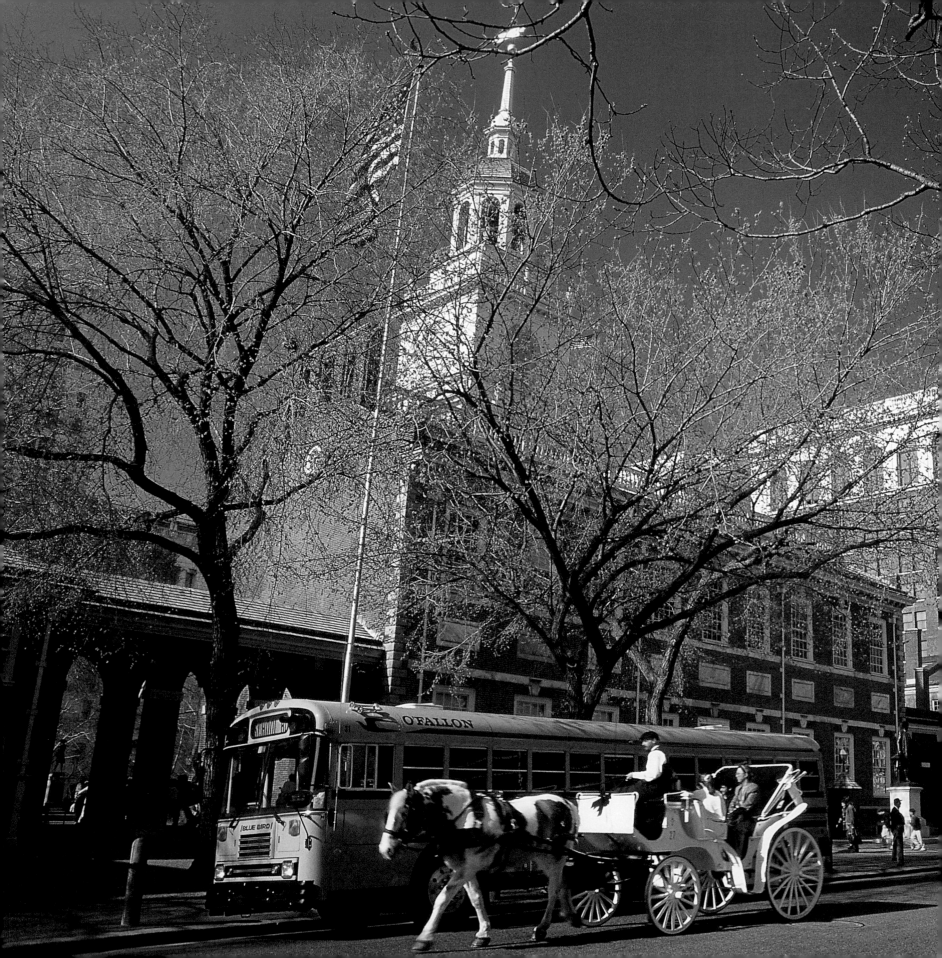

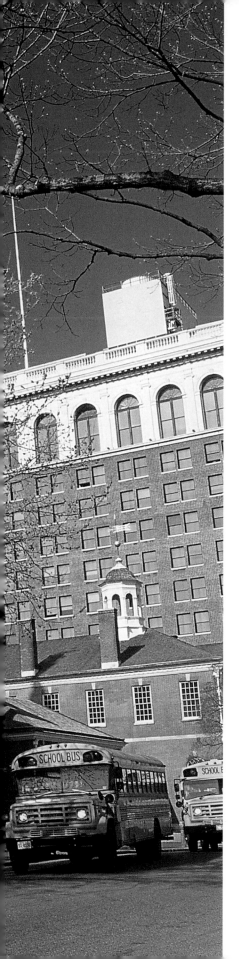

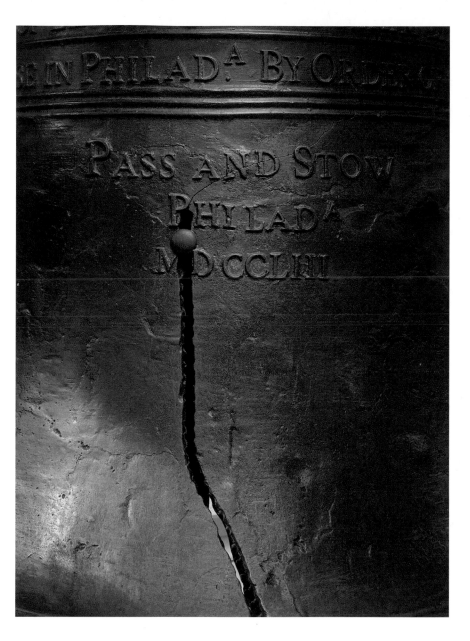

The Liberty Bell was removed from Independence Hall in 1976 and now stands inside a glass enclosure, a symbol of freedom. The bell's biblical inscription reads "Proclaim liberty throughout the land to all the inhabitants thereof."

Visitors enjoy a carriage tour past some of the sights at Independence National Historic Park, including Independence Hall, where the Founding Fathers signed the Declaration of Independence in 1776 and the Constitution 11 years later.

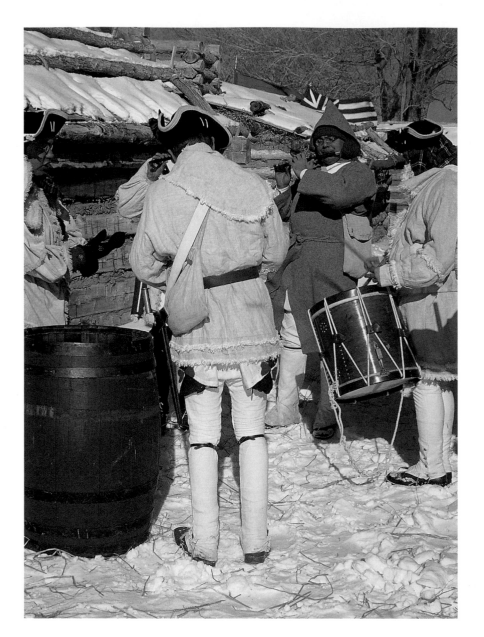

In the winter of 1777, after a brutal defeat by the British, George Washington and his troops regrouped outside Philadelphia at Valley Forge. More than 2,000 soldiers died as a result of harsh weather and a lack of supplies.

Valley Forge National Historic Park preserves Washington's headquarters, originally the home of a local miller, along with officers' quarters and fortifications.

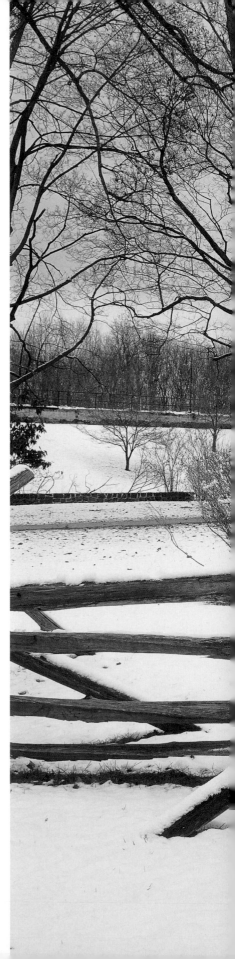

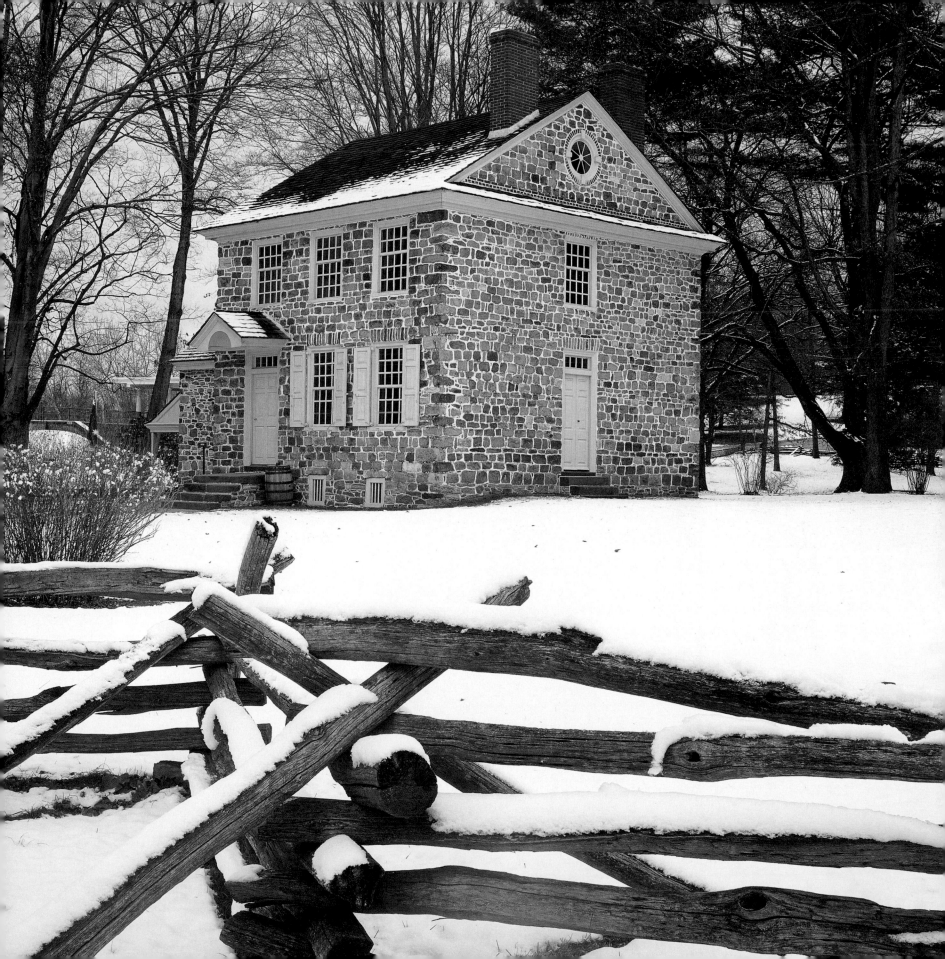

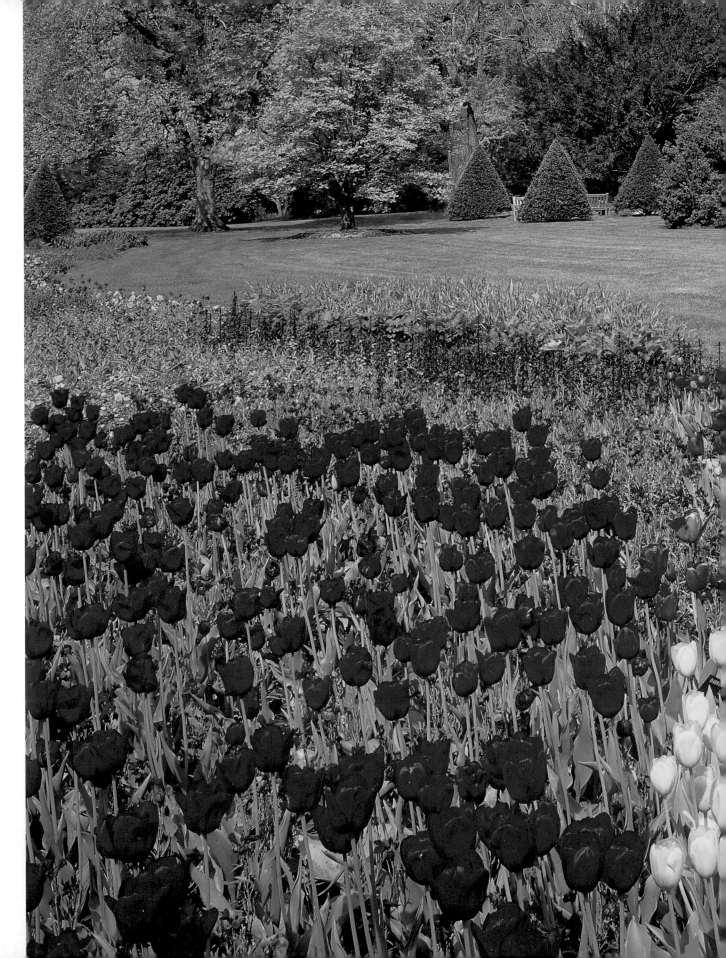

About 11,000 plant species flourish outdoors and in four acres of greenhouses at Longwood Gardens, originally the estate of Pierre S. du Pont. Having created a worldwide empire from his family's chemical business, du Pont spent his profits on gardening and conservation.

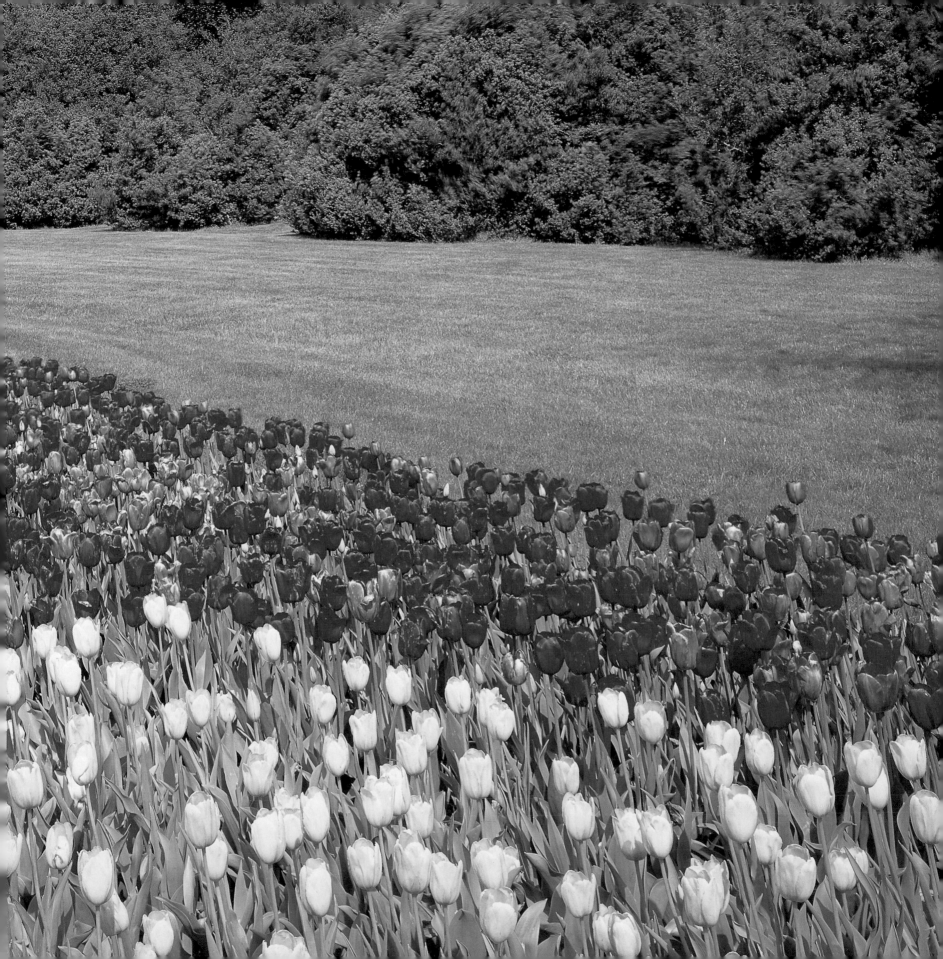

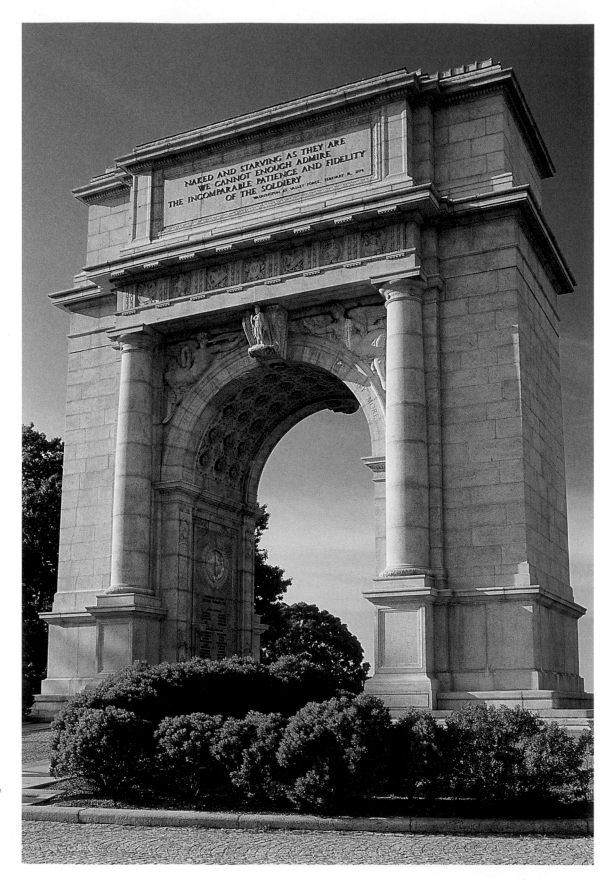

The National Memorial Arch, built at Valley Forge in 1917, stands in honor of the soldiers' loyalty. An inscription commends their "patience and fidelity" in the face of hardship.

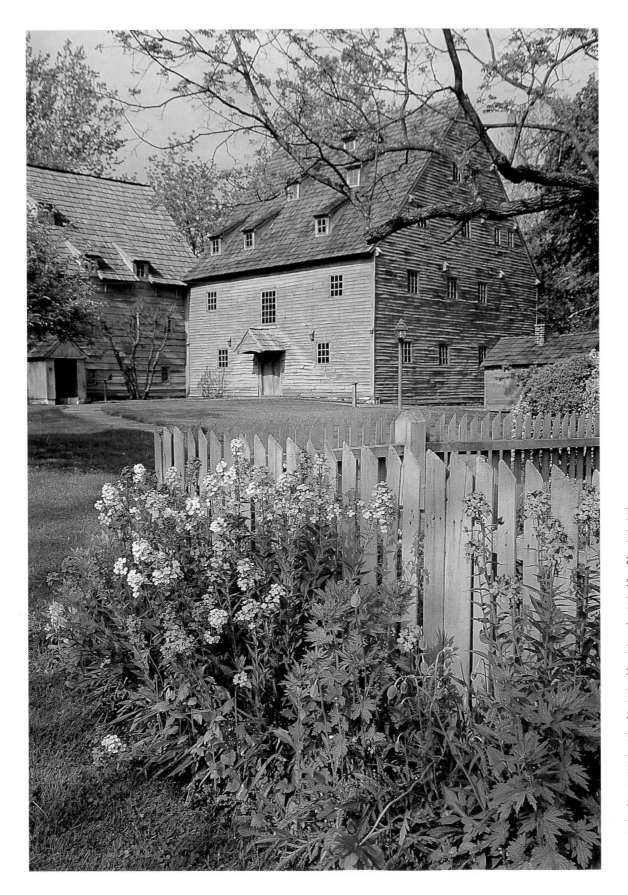

Founded in 1732, Ephrata Cloister— a small cluster of simple buildings in Lancaster County— was one of America's first communal societies. Members practiced celibacy and self-denial. The restored buildings, including a library of hand-lettered books, are now open to the public.

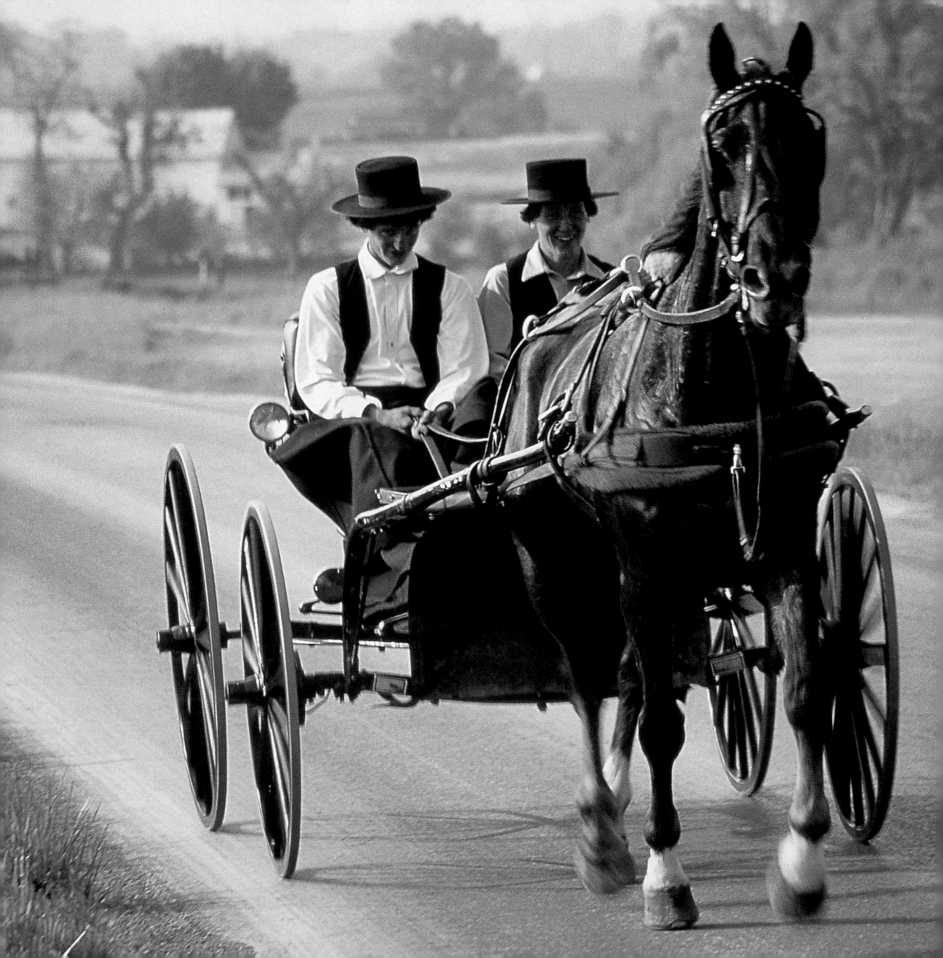

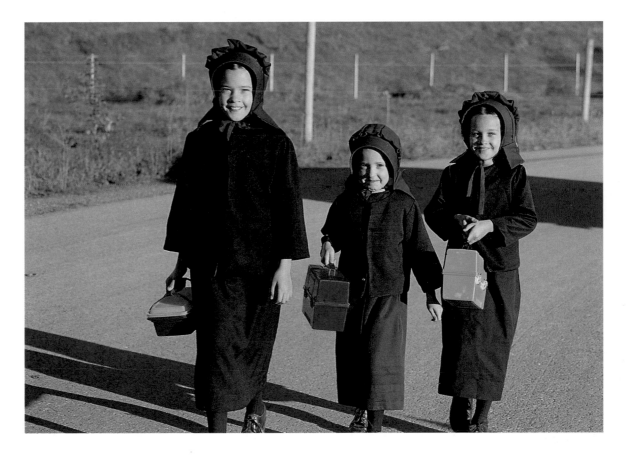

Old Order Amish girls in traditional and simple dress make their way to school. Most children attend school until the eighth grade, when they join family farms or businesses.

Known as the Pennsylvania Dutch, members of Amish, Mennonite, and Brethren sects have farmed in Lancaster County for centuries. Many of their ancestors fled religious persecution in Germany.

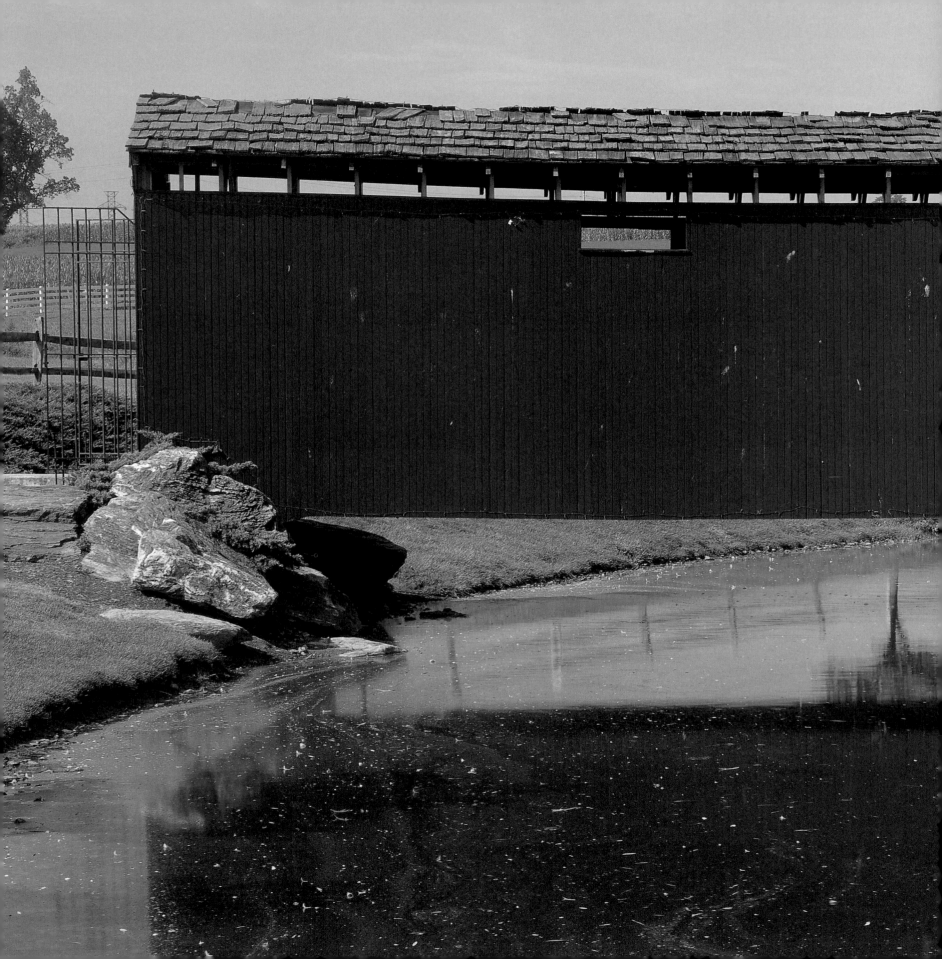

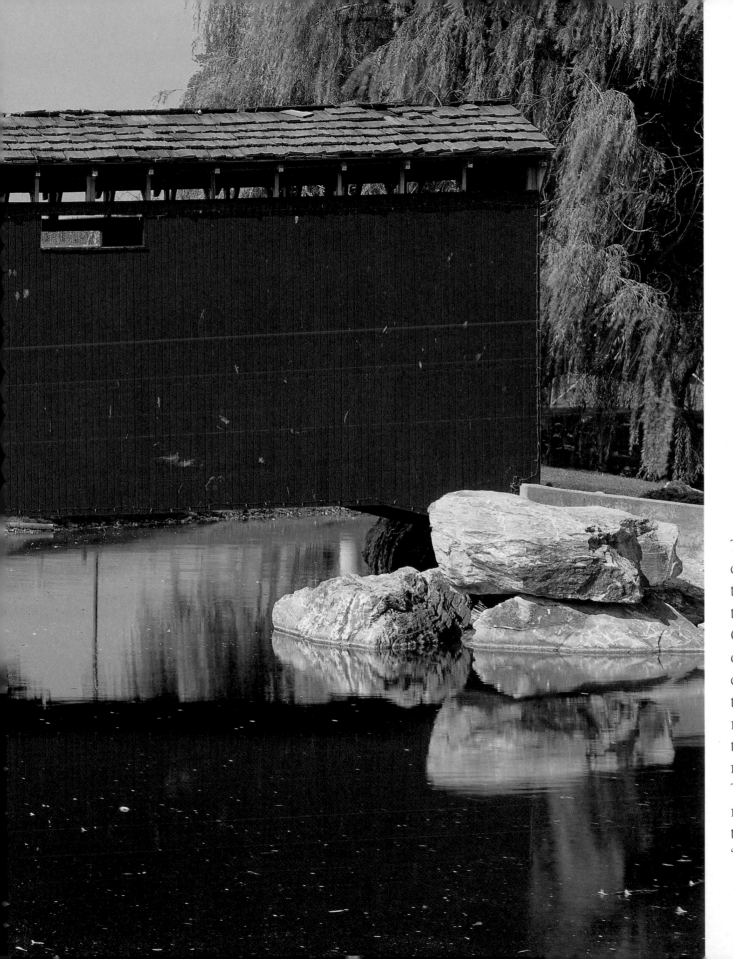

There are 219 covered bridges in the state—more than 25 in Lancaster County alone. Many of the bridges, covered to protect the wood from rotting, were built in the eighteenth and nineteenth centuries. Their shadowy recesses have earned them the nickname "kissing bridges."

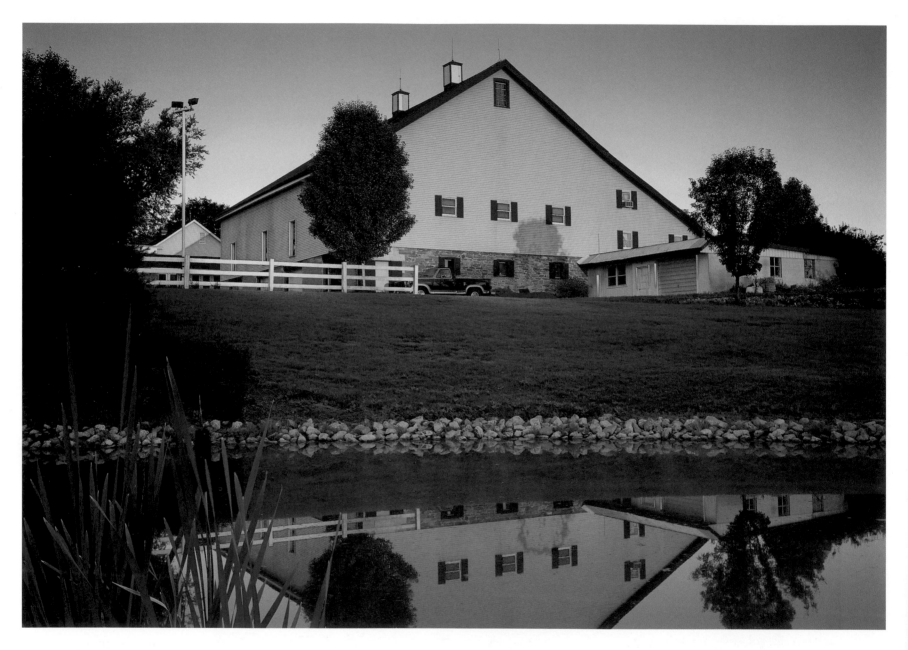

Pennsylvania was once covered by a vast forest, with white pine and hemlock in the north giving way to oak, chestnut, and hickory trees in the south. Today, even with thousands of farms spreading across the valleys, half of the state remains woodland.

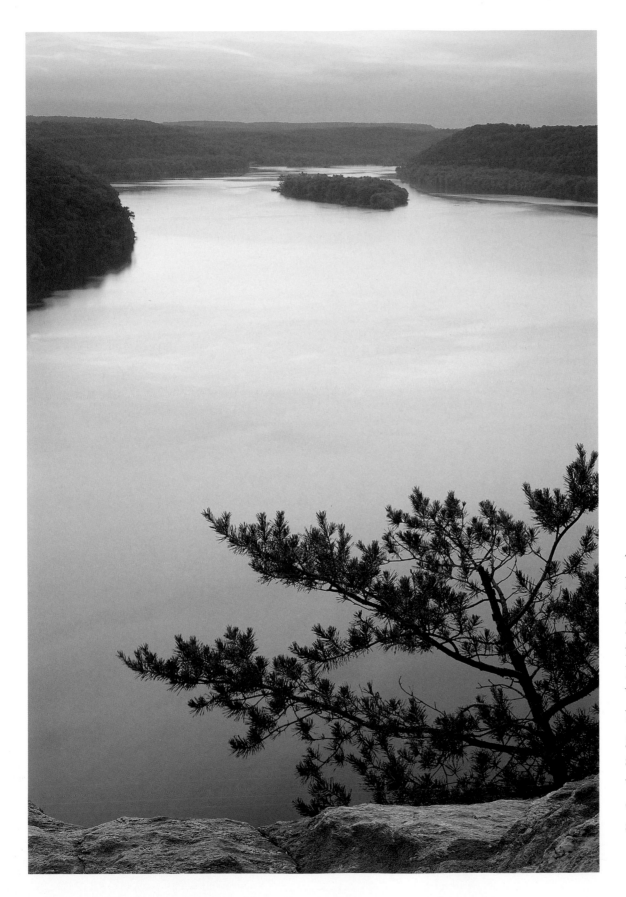

The Susquehanna
River and its
tributaries drain
27,500 square miles,
including parts of
Pennsylvania, New
York, and Maryland.
Up to 446 million
gallons each day
are drawn from the
waterways for resi-
dential, industrial,
and agricultural uses.

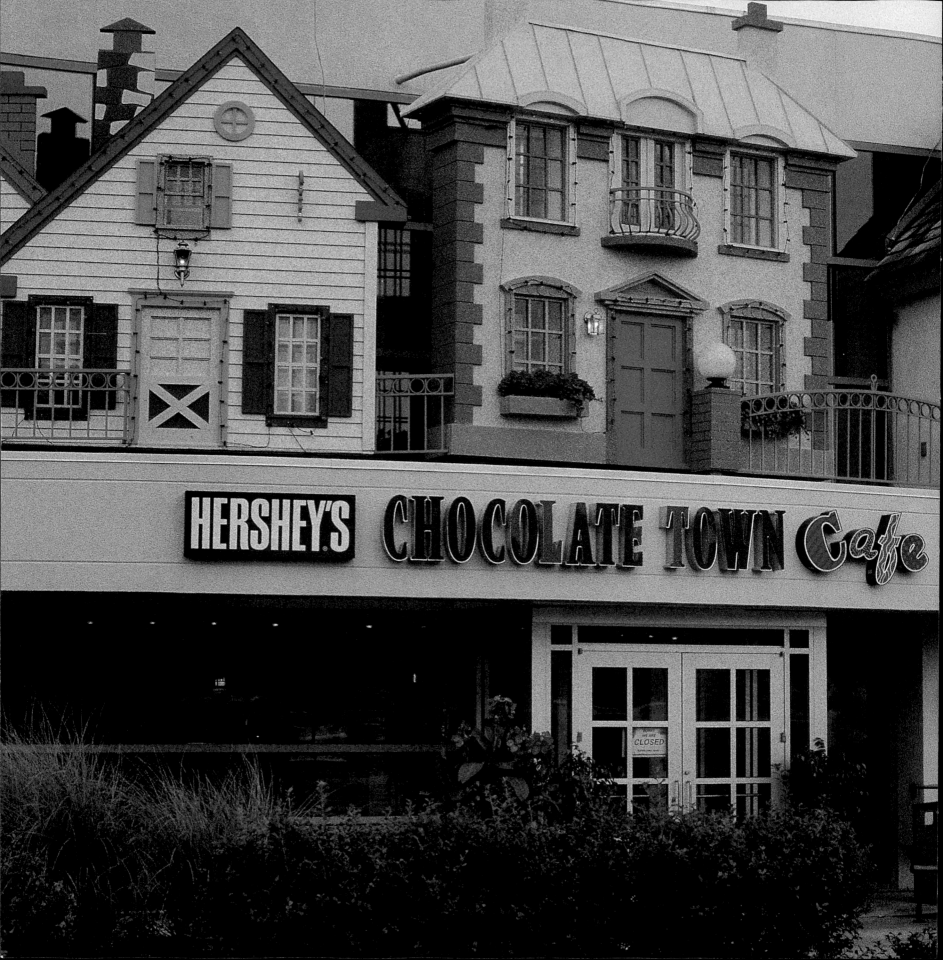

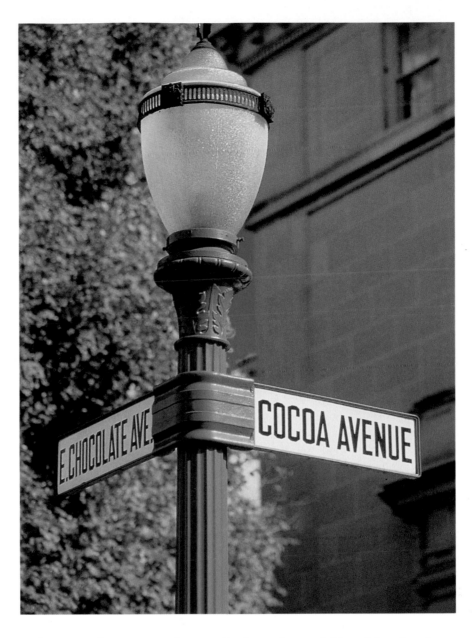

Whimsical signs and streetlights shaped like Hershey's Kisses direct visitors around the town. The famous plant can produce 33 million candy kisses in a day.

Milton S. Hershey founded the Hershey Chocolate Company in 1894. More than a hundred years later, the community of Hershey—complete with an amusement park and resort—attracts 1.5 million visitors a year from around the world.

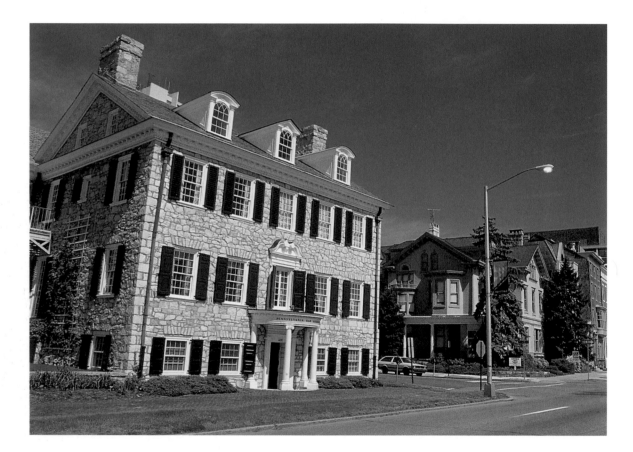

Sightseers in Harrisburg can stop at the home of William Maclay, the state's first U.S. senator. Maclay helped plan the city in the early 1700s, along with trader and ferry owner John Harris Jr.

The Renaissance-style State Capitol boasts a 52-million-pound, 272-foot-high dome, inspired by the dome of St. Peter's Basilica in Rome. President Teddy Roosevelt dedicated the building in 1906.

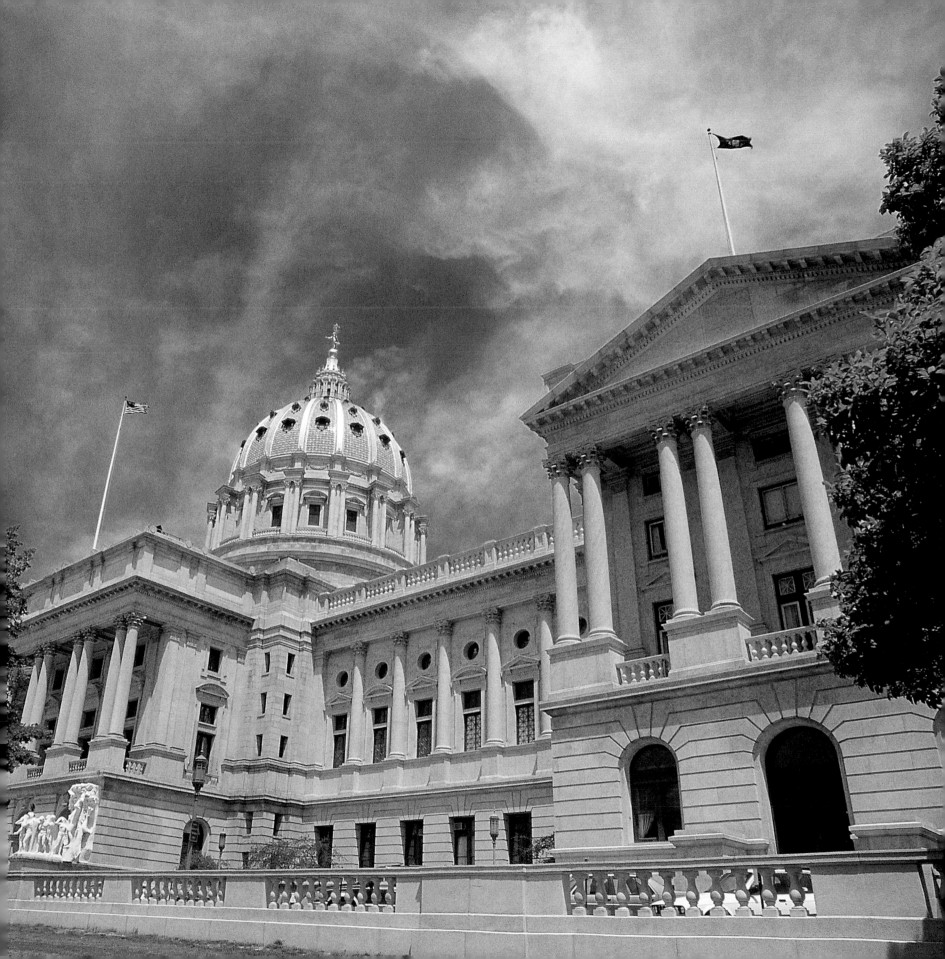

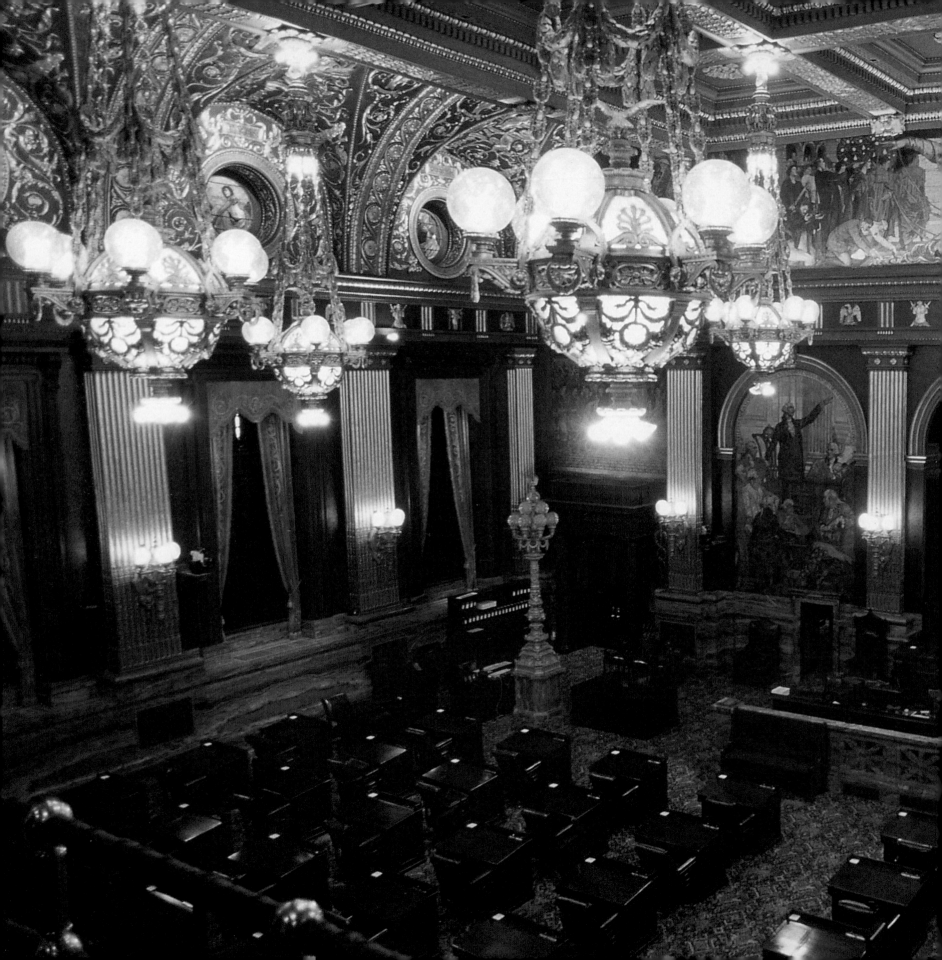

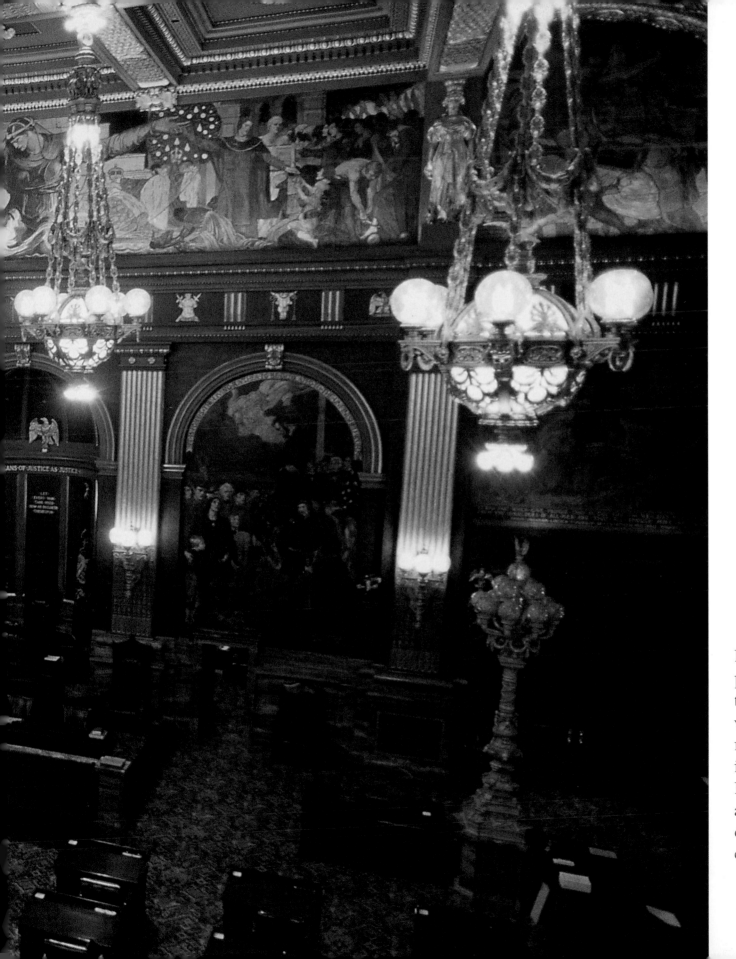

More than 100,000 people each year tour the State Capitol, wandering from the main hallway, with its painted tiles of Pennsylvania's flora and fauna, to the ornate senate chamber.

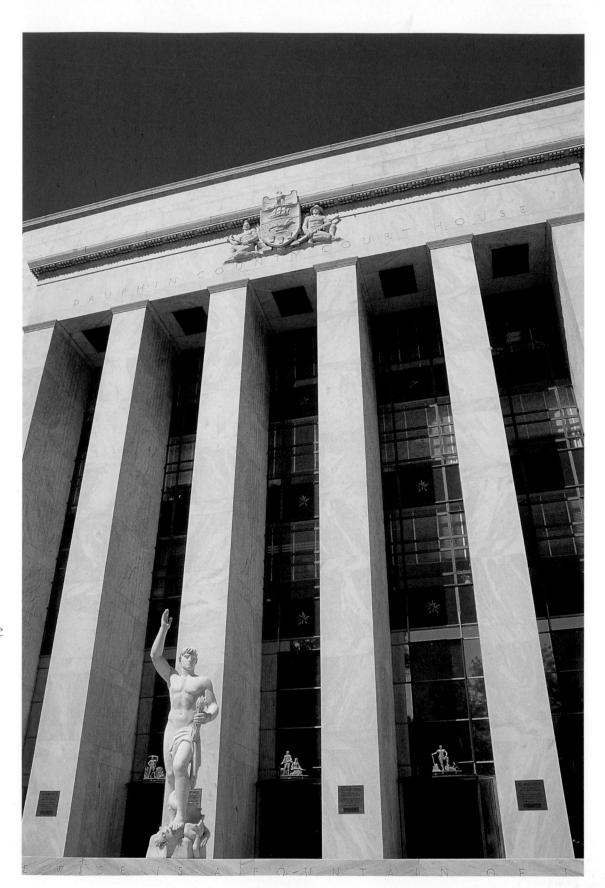

Dauphin County Court House adds a stately air to downtown Harrisburg. The city was chosen as the state capital in part for its location on the Susquehanna River. It became a hub for the canal system, and later a center for railway and highway travel.

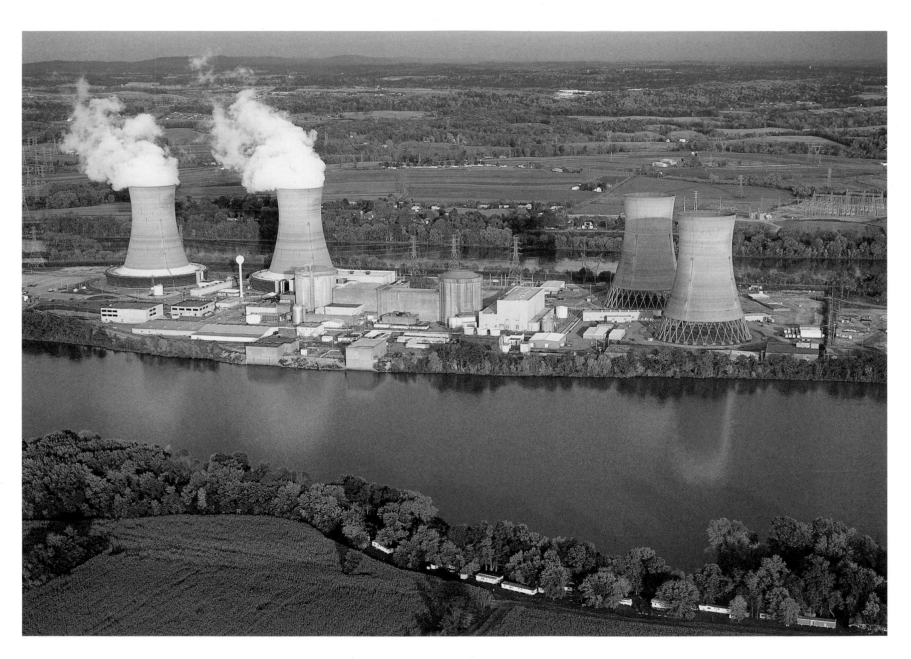

Three Mile Island was the site of the nation's most serious nuclear disaster on March 28, 1979. After a cooling process failed, a series of mechanical and worker errors led to leaking radiation. Although no one was killed, the accident led to the reform of power plants across the continent.

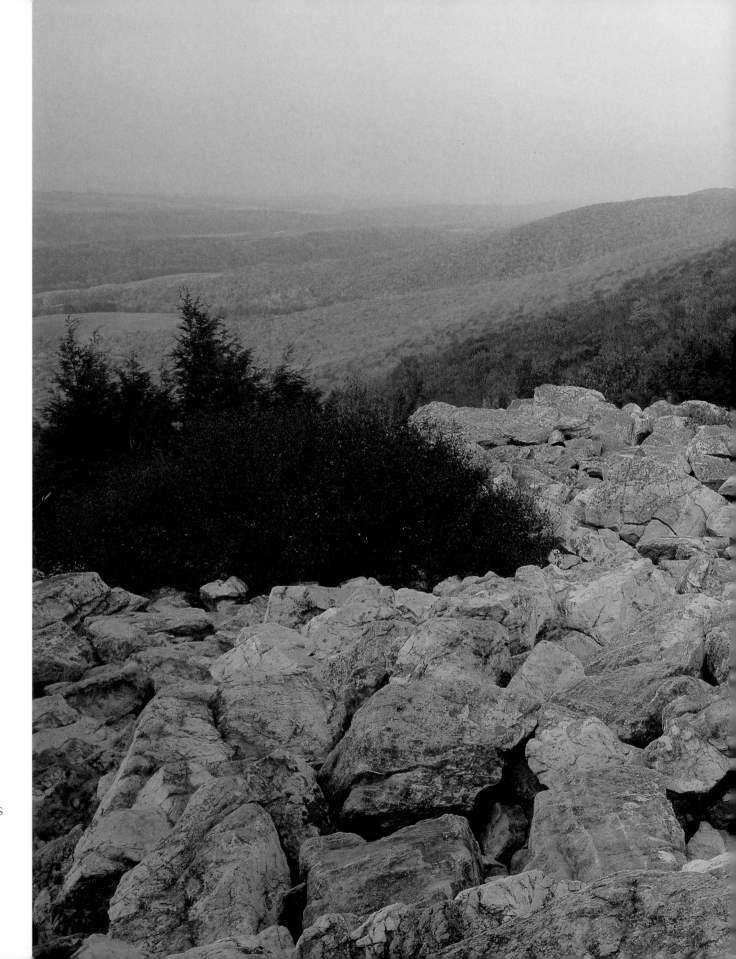

Hawk Mountain in Schuylkill County is just one stop on the Appalachian Trail, a grueling route from Maine to Georgia that attracts thousands of backpackers each year.

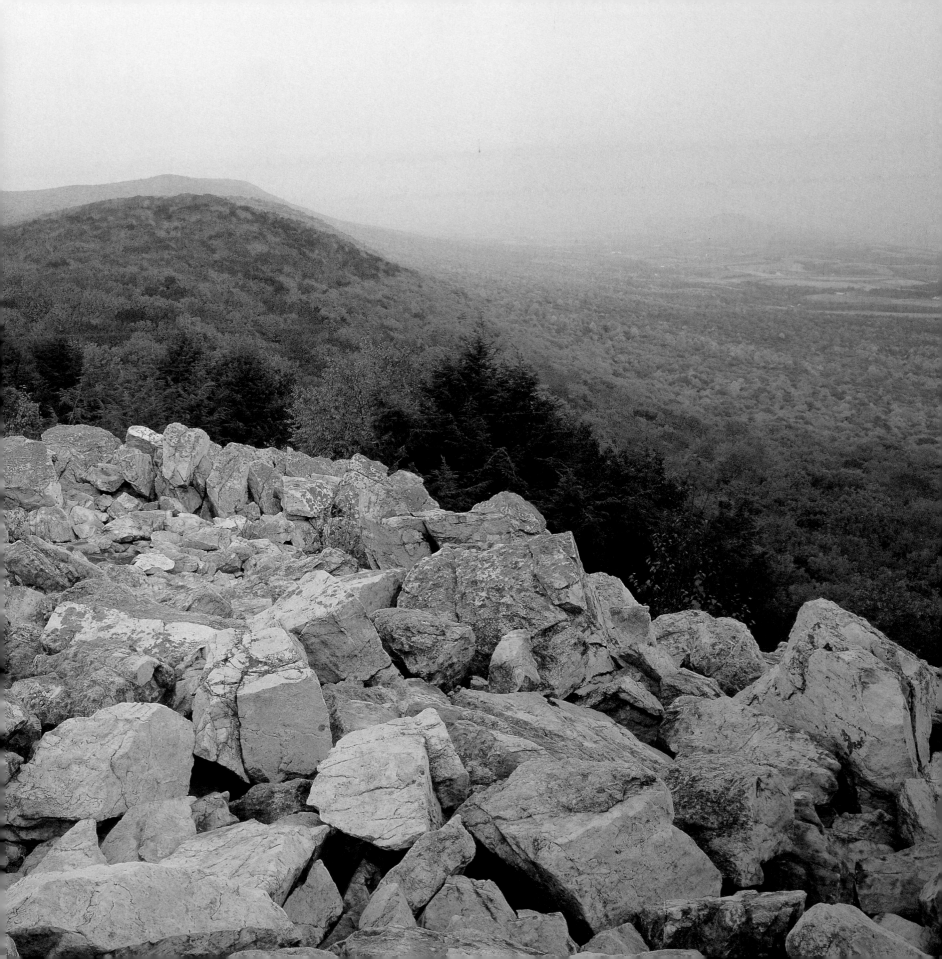

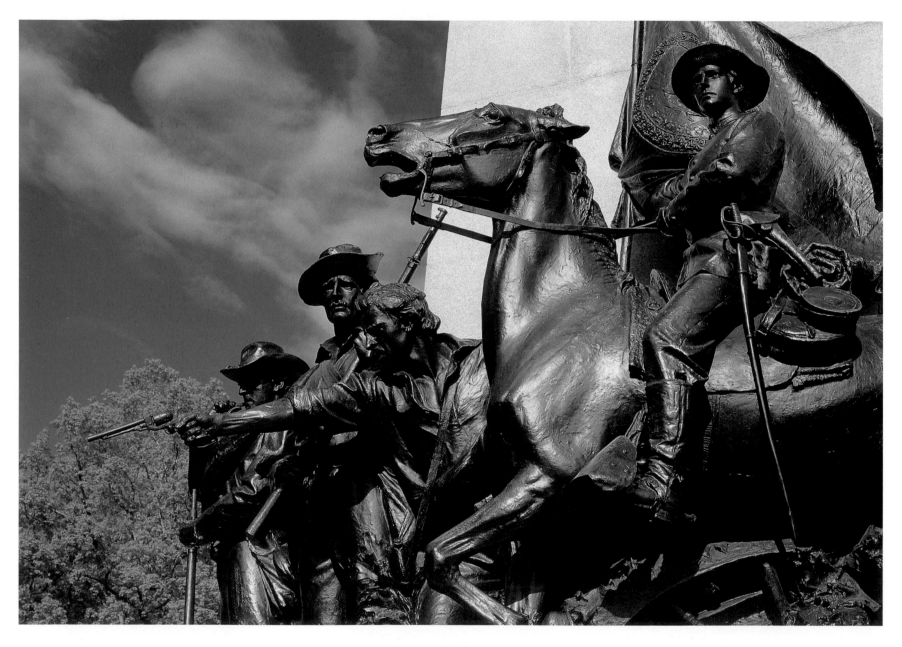

More than 51,000 soldiers died in 1863 at Gettysburg, the largest
and bloodiest battle in the Civil War.

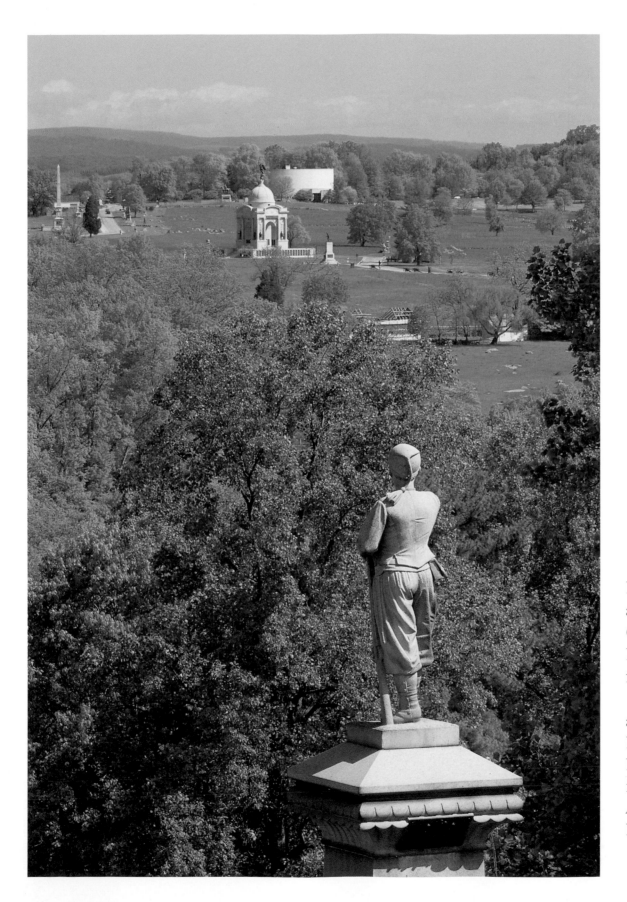

Extending over almost 6,000 acres, Gettysburg National Military Park includes more than 1,400 monuments and memorials. President Abraham Lincoln gave his famous Gettysburg Address here on November 19, 1863.

Upon retirement, President Dwight D. Eisenhower bought a 189-acre farm near Gettysburg. Though no longer a presidential retreat or a meeting place for world leaders, the reserve is a national historic site and a working farm.

Gettysburg was a commercial center in the 1800s, situated at the crossroads of four major supply routes. Unfortunately, its position made it a strategic target in the Civil War.

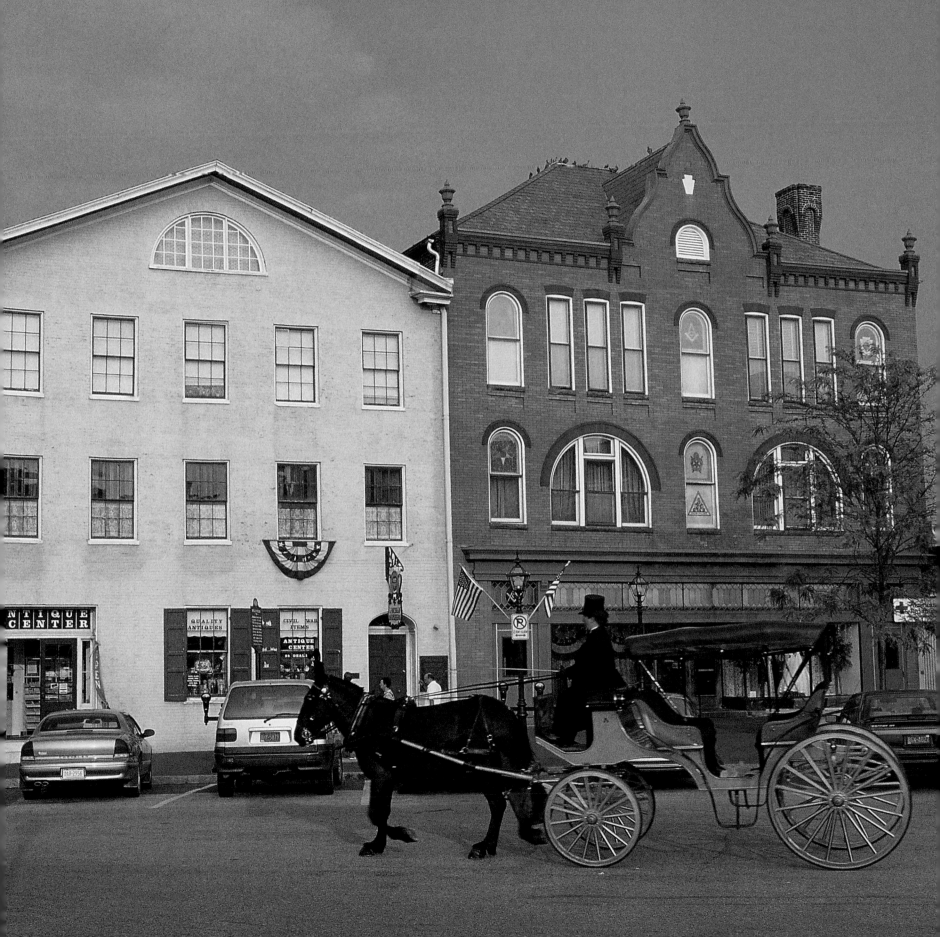

Penn State University has a progressive reputation. It awarded the first degrees in agriculture in 1861, pioneered research in peaceful uses for atomic energy, and founded a graduate program for Native Americans in 1970.

Hiking trails at Black Moshannon State Park wind past lakes and wetlands, forest groves, and wildflower clearings. In winter, the trails make perfect cross-country ski routes.

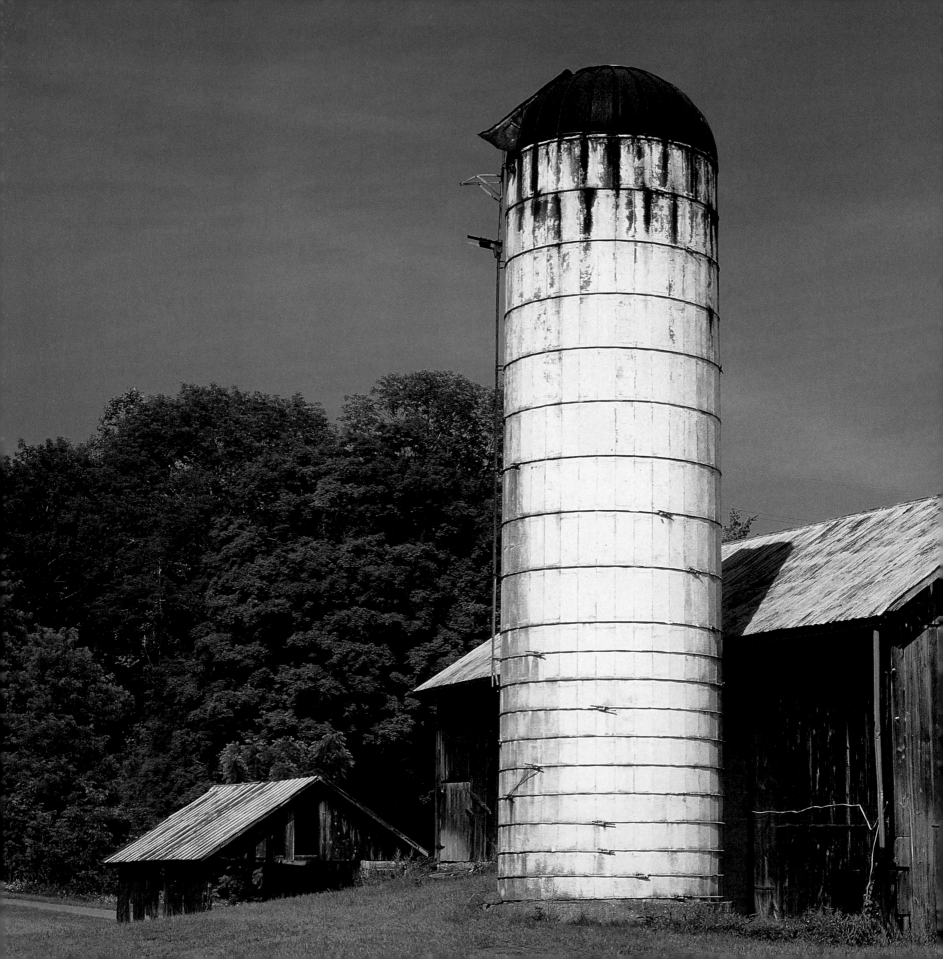

Huntingdon County is a combination of forested hills and farming valleys. About 22 percent of the area is agricultural land— communities and industrial sites make up only 4 percent.

47

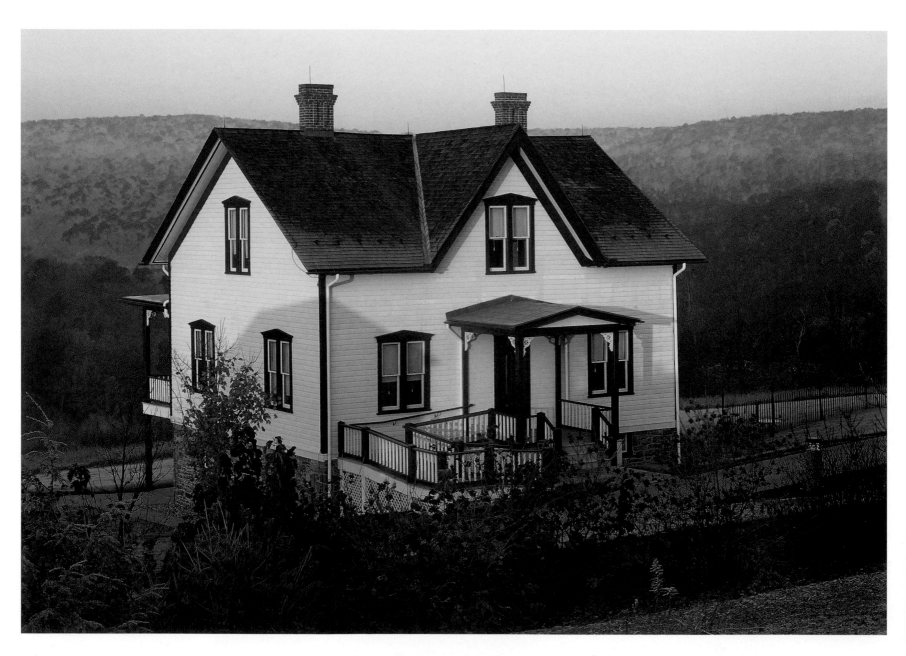

In 1889, a poorly maintained dam on the Little Conemaught River burst, spilling 20 million tons of water into a raging wave that swept through Johnstown, killing more than 2,000 people. The Johnstown Flood National Memorial provides an up-close look at the causes of the flood and the devastation it wreaked.

Viburnum blooms on the banks of the Little Conemaught River. The serene scene is a startling contrast to the photos and films on display at the nearby flood memorial.

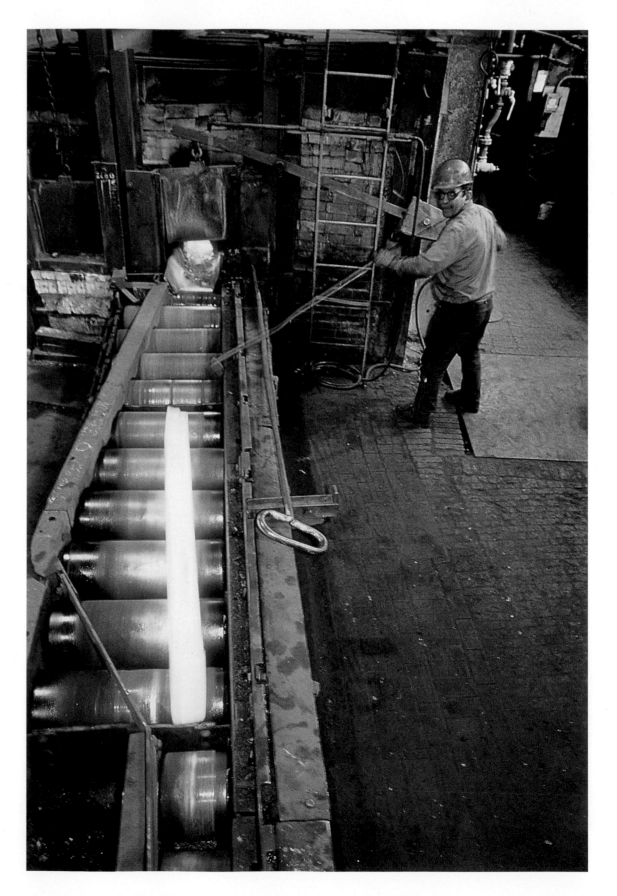

A worker shapes a steel rod in a mill near Johnstown. In the late 1800s, the process of steelmaking was perfected in this area, and mills produced many of the rails for the expanding railways of the time.

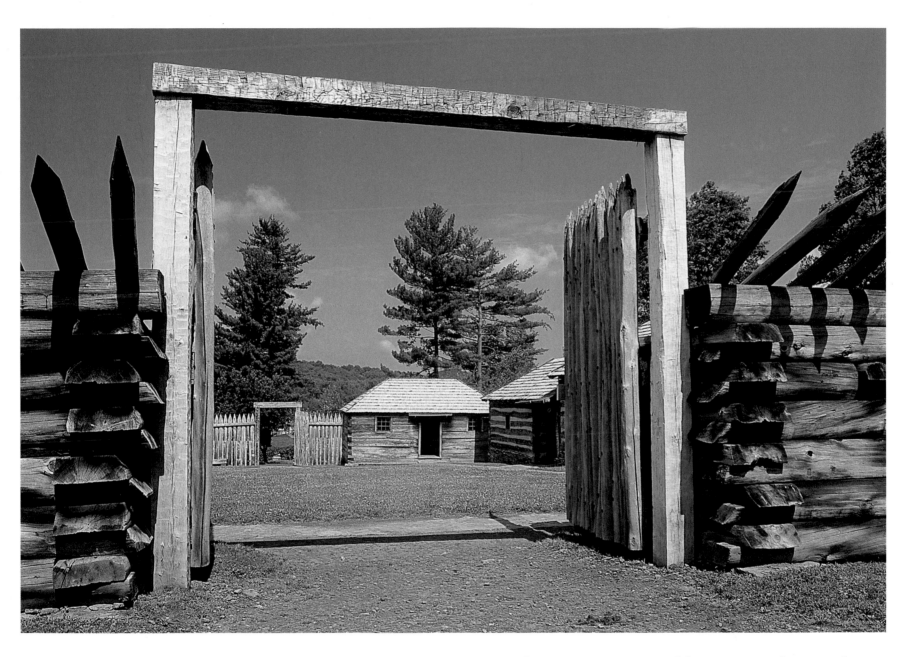

Fort Ligonier stood as an insurmountable point on the British front from 1758 to 1766, during the French and Indian War of the 1700s. Never surrendered, the fort was completely restored and rebuilt as a historical attraction in the 1950s.

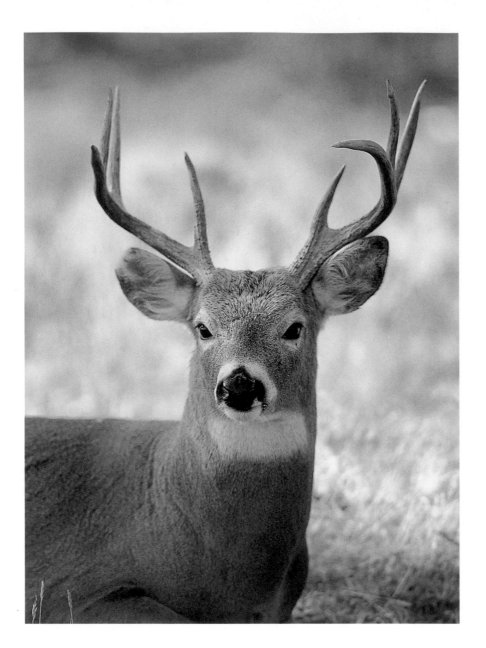

Home to white-tailed deer, ring-necked pheasants, and mink, Laurel Hill State Park is also a favorite haunt of swimmers, anglers, and ice-fishers.

Widely considered Frank Lloyd Wright's greatest masterpiece, Fallingwater hangs over a waterfall and its cantilevered design echoes its surroundings. The house was built near the community of Ohiopyle for Edgar J. Kaufmann Sr. in 1932. It is now open to the public.

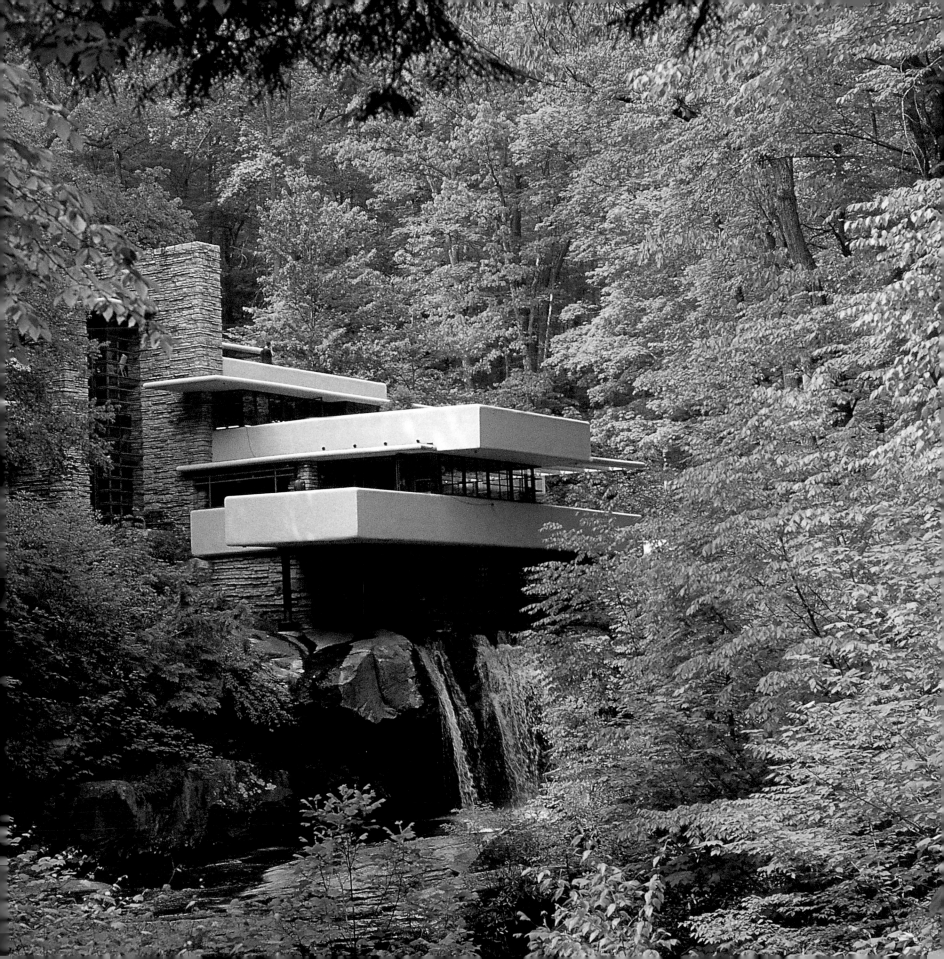

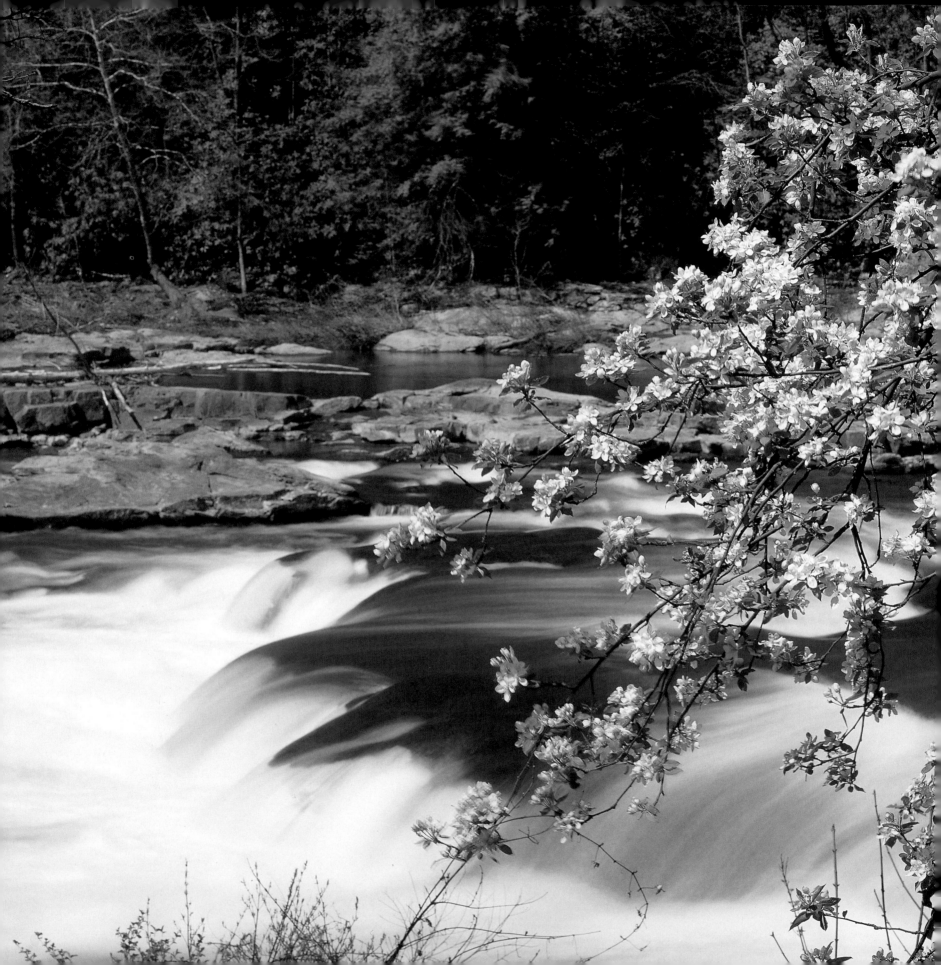

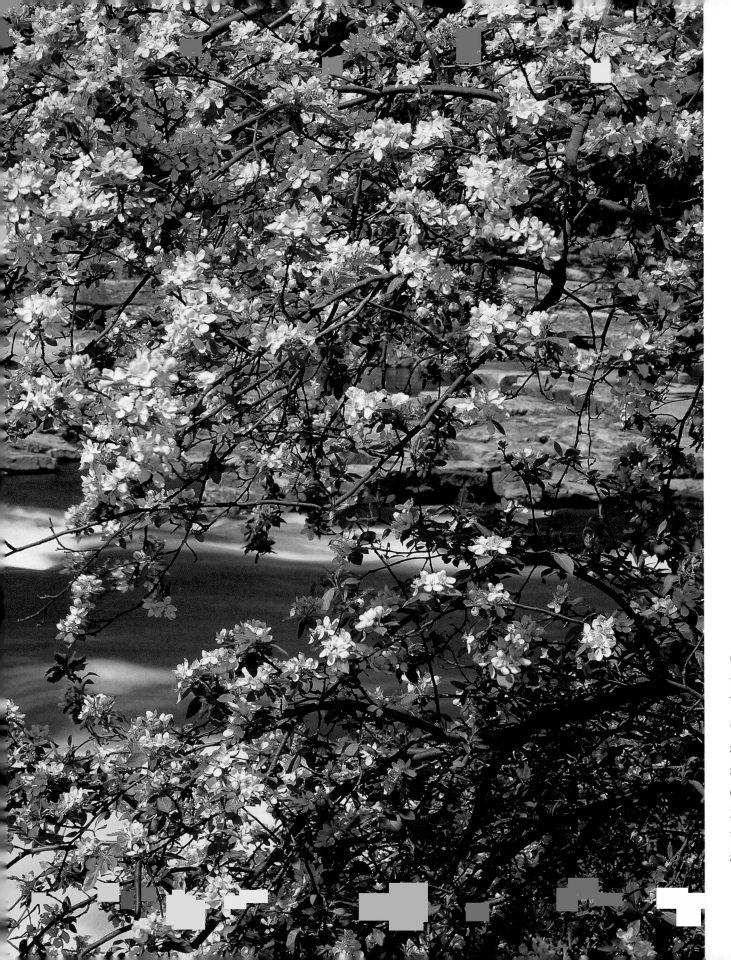

Once polluted by upstream mining, the Youghiogheny River Gorge has been saved and revived by massive conservation efforts. Ohiopyle State Park now protects 19,000 acres around the river.

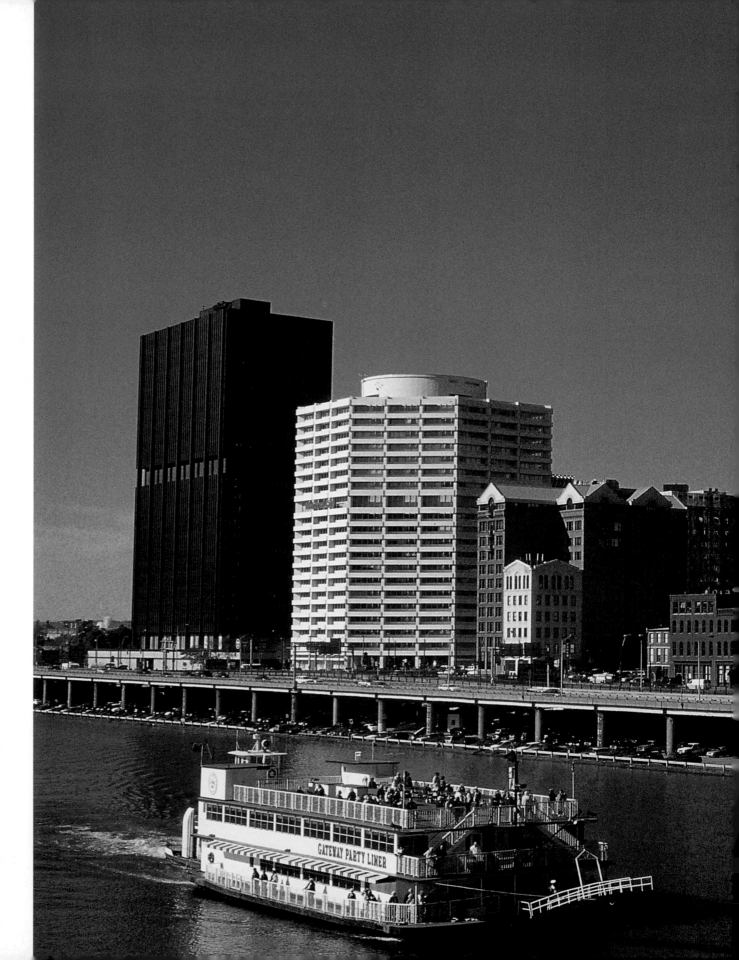

Pittsburgh's location at the confluence of the Monongahela and Allegheny rivers made it a strategic site for early trading powers. French and British forts stood here in turn.

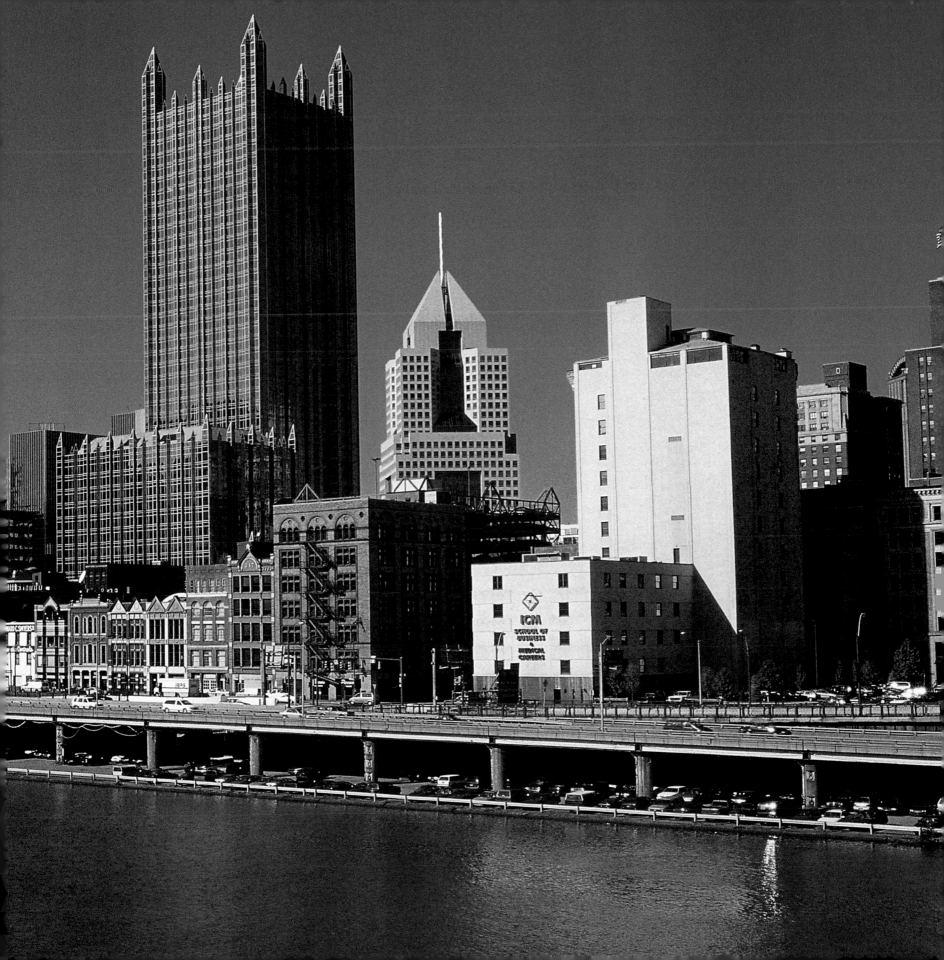

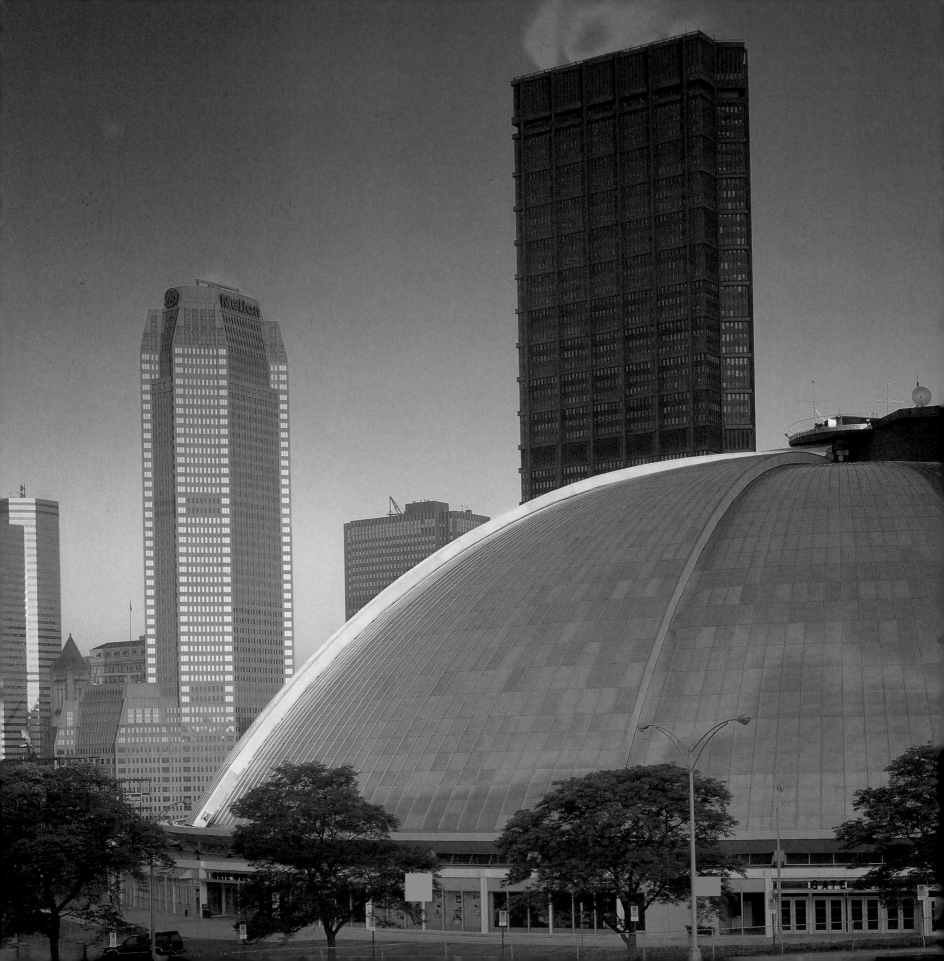

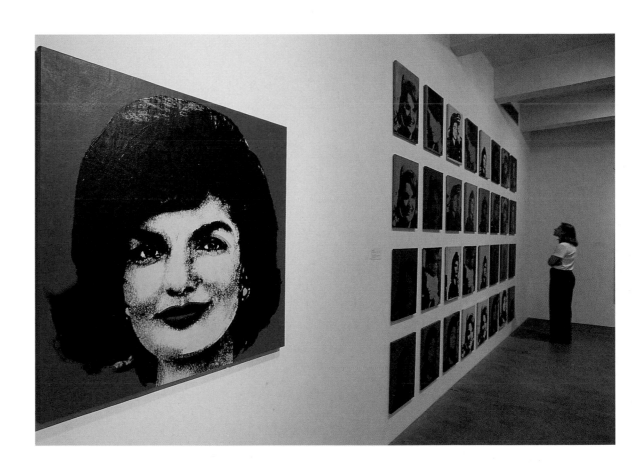

Artist Andy Warhol was born and educated in Pittsburgh. The Andy Warhol Museum provides a captivating tour of 500 works, including advertising projects and some of his most famous portraits.

Hockey fans in Pittsburgh cheer for the Penguins at the Civic Arena, locally known as the Igloo. Other sports fans follow Pirates baseball and Steelers football at Three Rivers Stadium.

In 1816, Pittsburgh was already a city of 10,000 people. Before the end of the century, it was home to steel mills, aluminum plants, and the Henry J. Heinz factory.

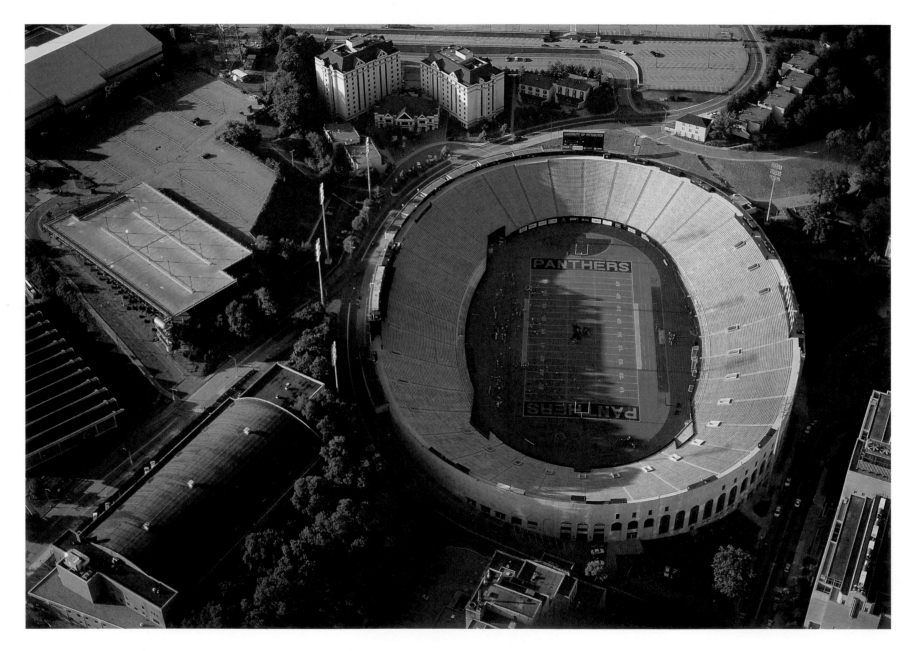

Carnie Smith Stadium is home to Pittsburgh State University's
Gorillas. The football team has played here for more than
75 years and won 70 percent of their home games.

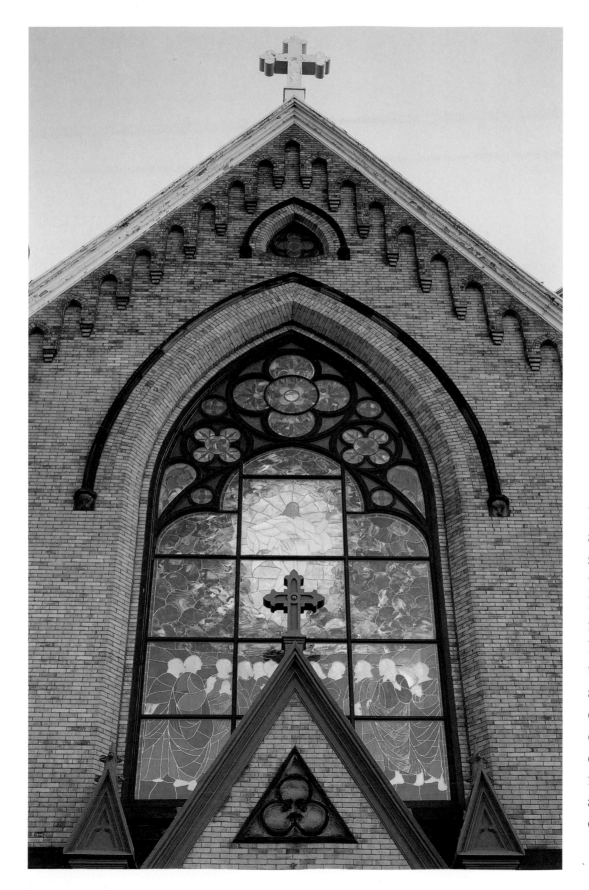

Long before the arrival of European soldiers and settlers, part of what is now Pittsburgh served as a native burial ground. By the late 1800s, the city was thriving and more than 20 churches dotted the district. Today, most congregations have moved to suburban areas, but six remain downtown.

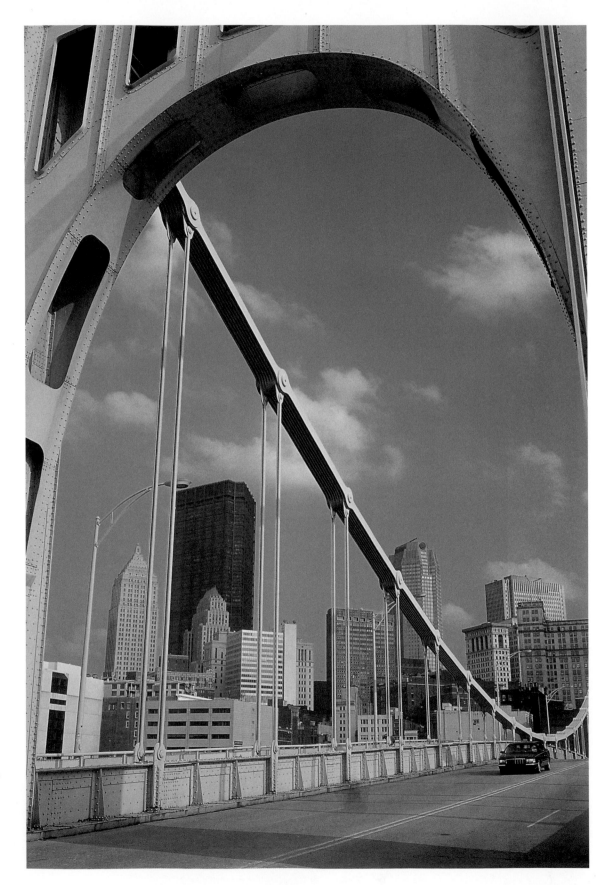

With almost four million people visiting Pittsburgh each year, guests outnumber residents by 10 to 1 on the average evening.

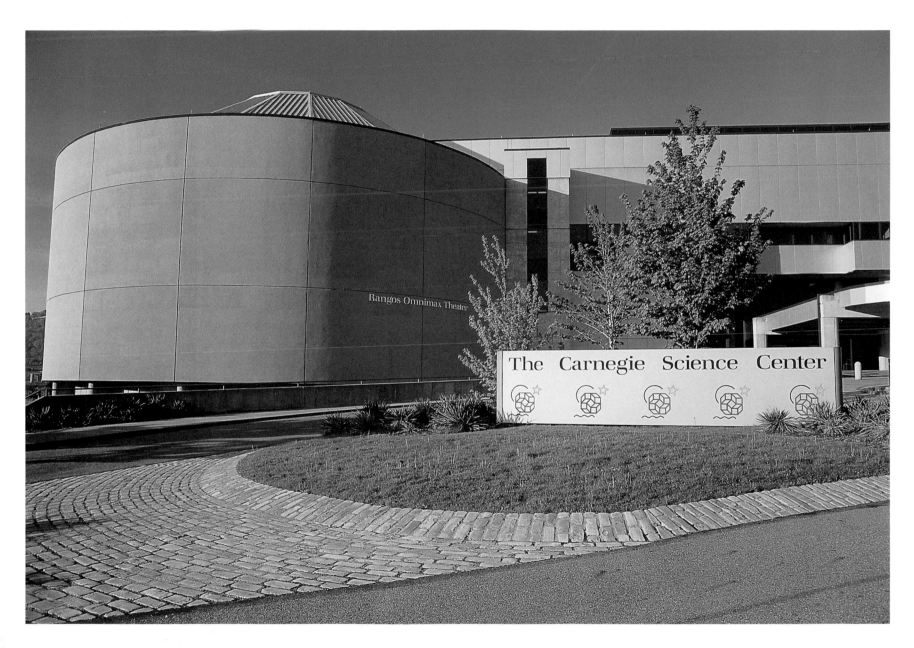

Andrew Carnegie arrived from Scotland at the age of 13. Though a ruthless businessman, he was also a generous philanthropist. The Carnegie Science Center is just one of the monuments to his name.

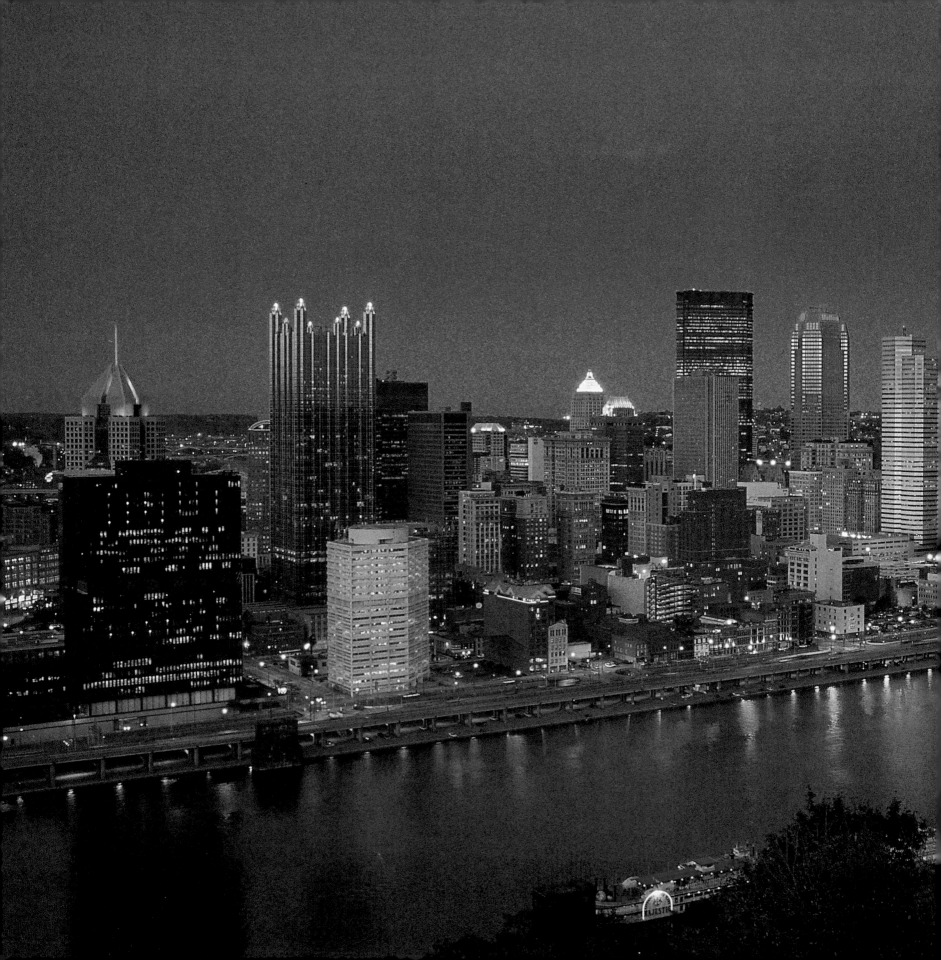

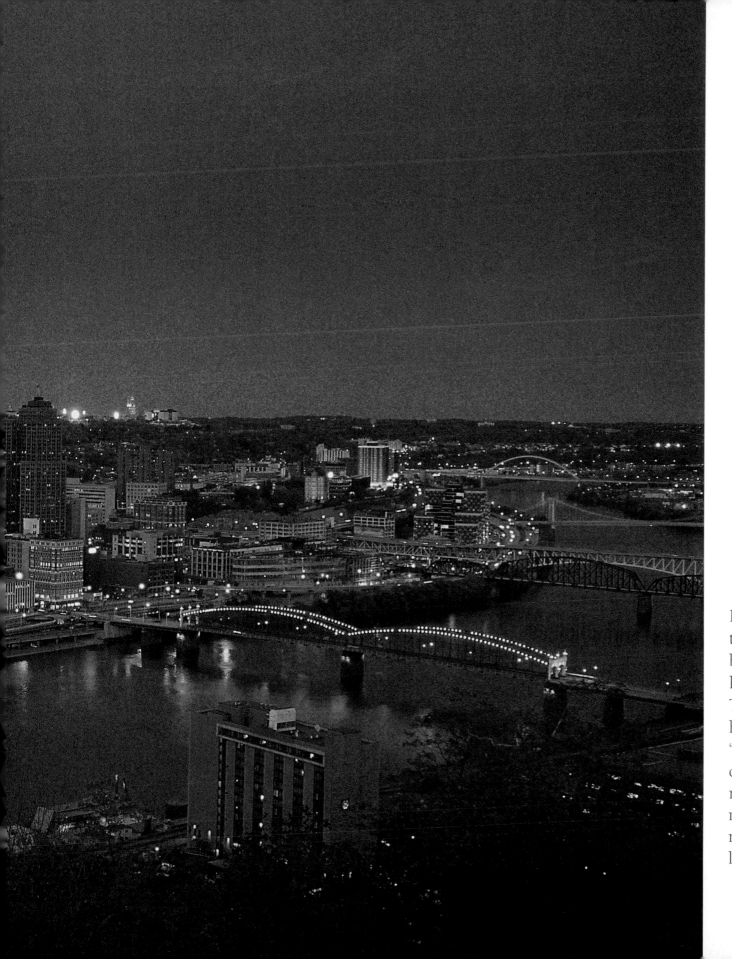

Pittsburgh's downtown district, framed by three rivers, is known as the Golden Triangle. The area has undergone many "renaissance" periods of building and restoration, and is now one of the nation's safest and liveliest city centers.

First a military outpost, important for its location on the shores of the Great Lake, Erie was settled in the late 1700s. Farming and lumber were the first industries, and the county continues to be an industrial center.

With lakeshore, wetland, and forest habitat, Presque Isle State Park supports more than 500 plant species. The park also protects an array of birds, including sandpipers and blue herons.

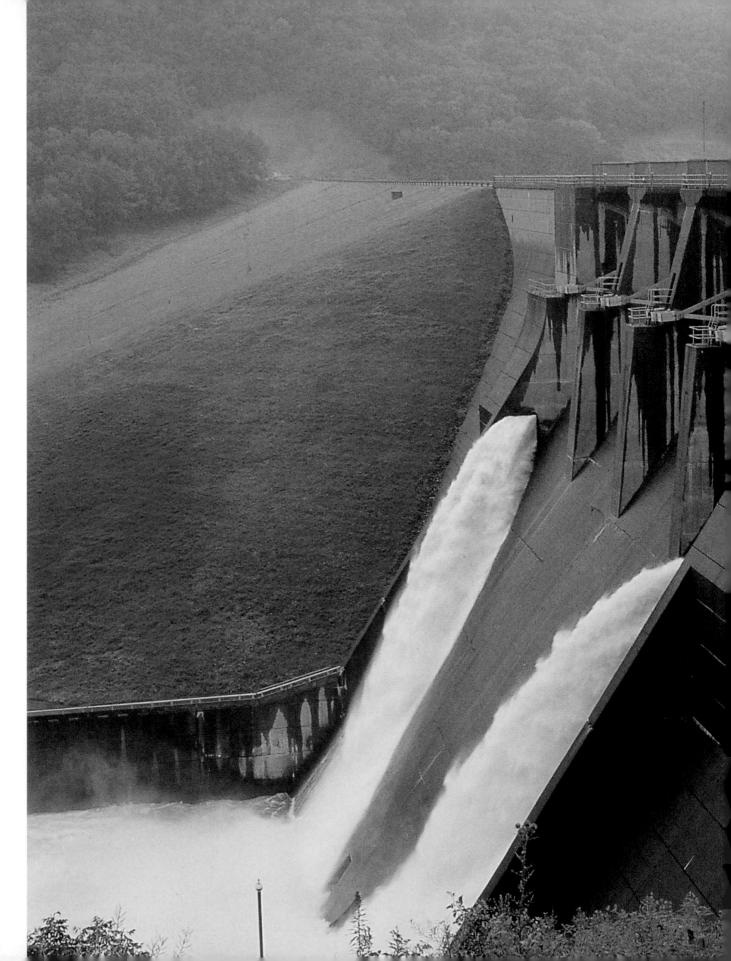

To control flooding, the U.S. Army Corps of Engineers built Kinzua Dam in 1965. The result was Allegheny Reservoir, a 12,000-acre body of water offering 91 miles of shoreline and unlimited boating opportunities.

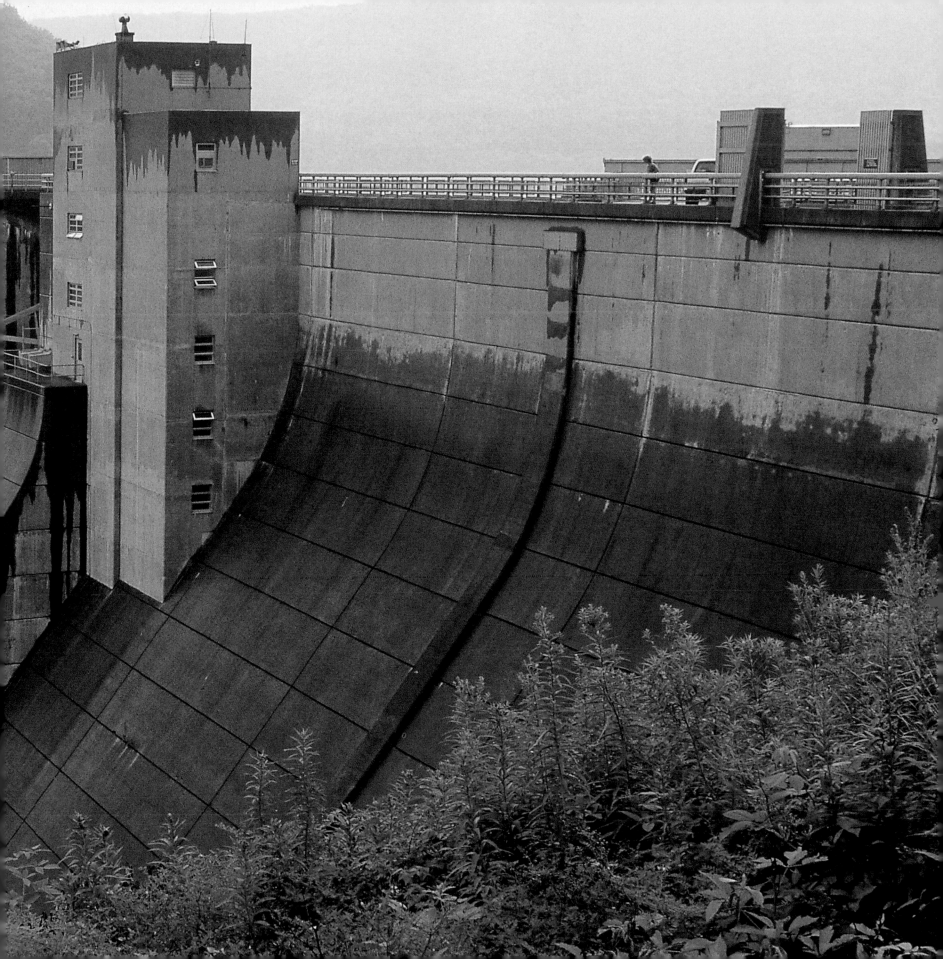

Pennsylvania's only national forest, Allegheny encompasses 516,000 acres, stretching across the New York border. Numerous hiking trails crisscross the forest, along with paths for horseback riders and cross-country skiers.

After Pennsylvania's famous fall colors have faded, lows can reach 20°F. In summer, temperatures soar to the high 80s.

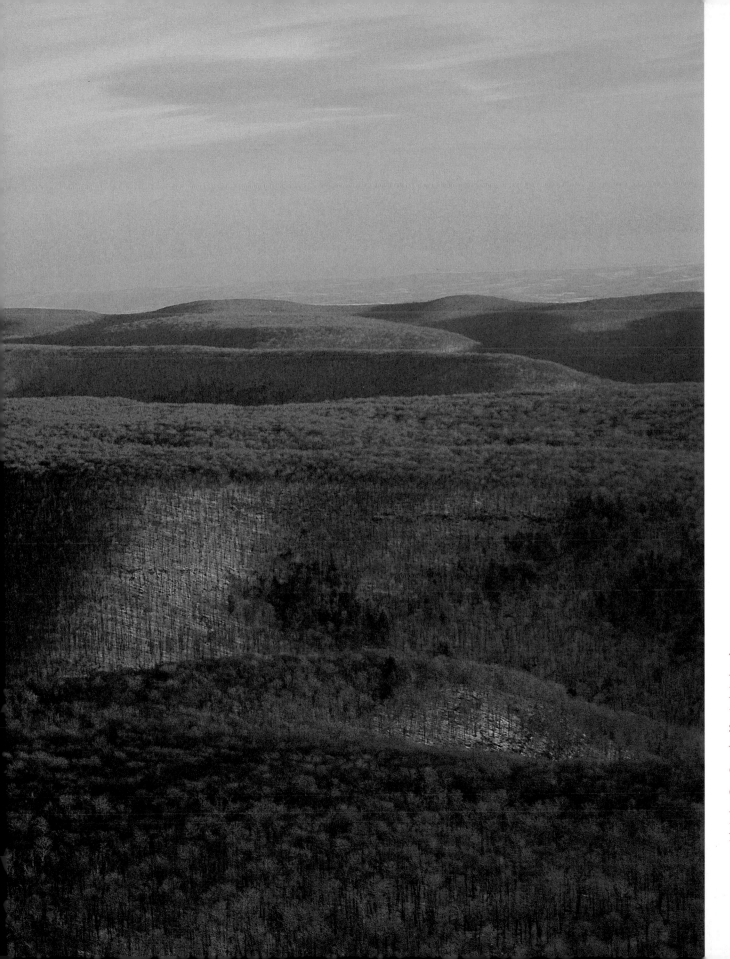

Twenty-six miles of hiking trails lead hardy explorers to some of the best views in Ricketts Glen State Park. One of the largest parks in Pennsylvania, it encompasses 13,050 acres.

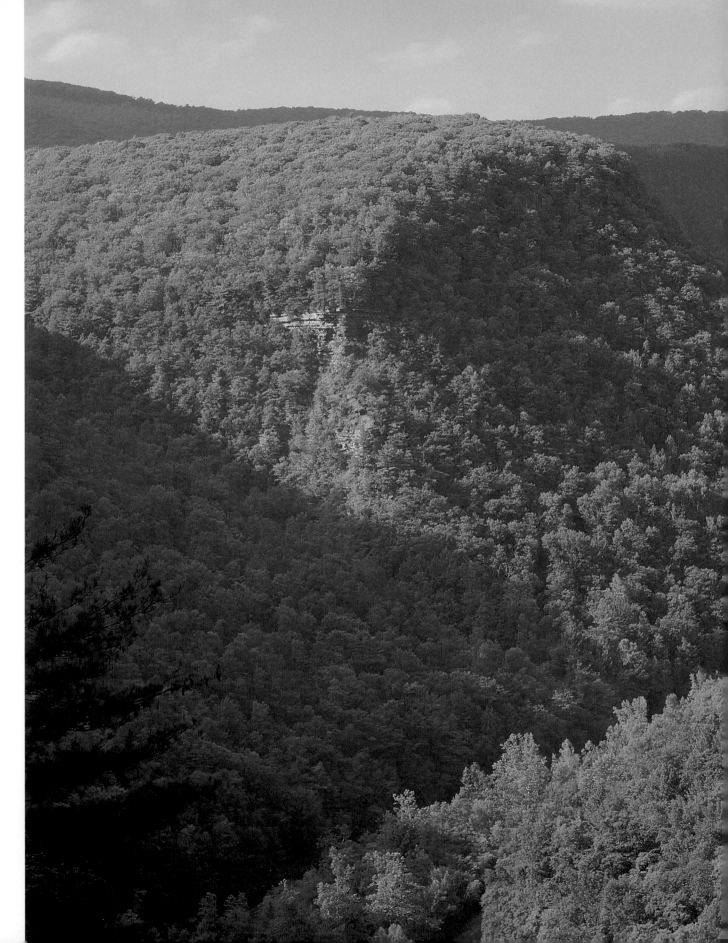

Far below the cliff tops, Pine Creek runs for 50 miles through what is known as Pennsylvania's Grand Canyon, carved by melting glaciers about 20,000 years ago. One edge of the gorge is protected by Colton Point State Park, named after one of the area's early lumbermen.

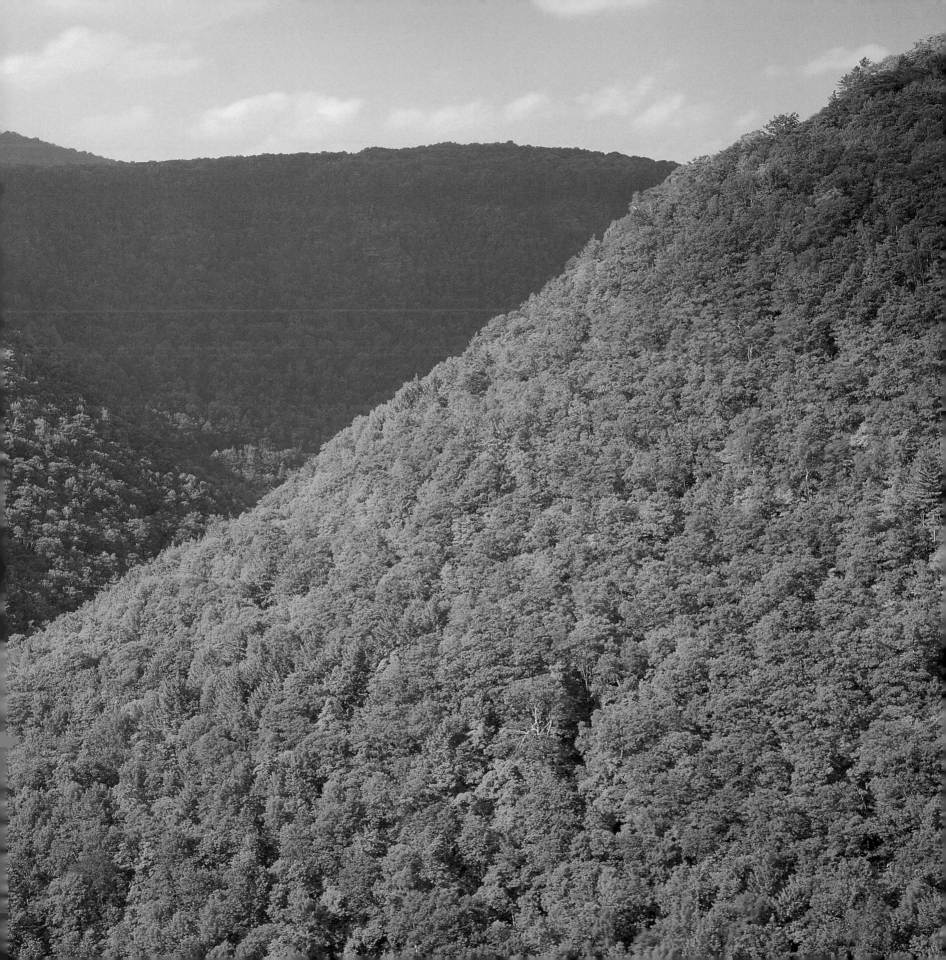

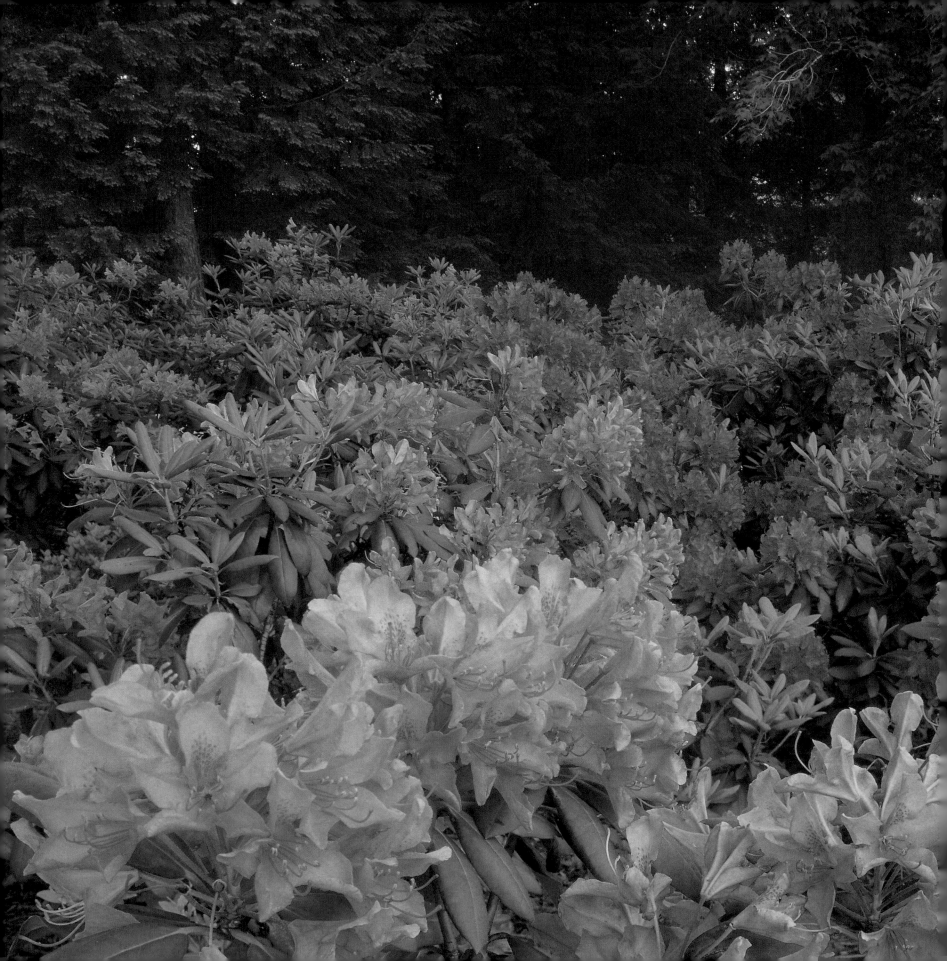

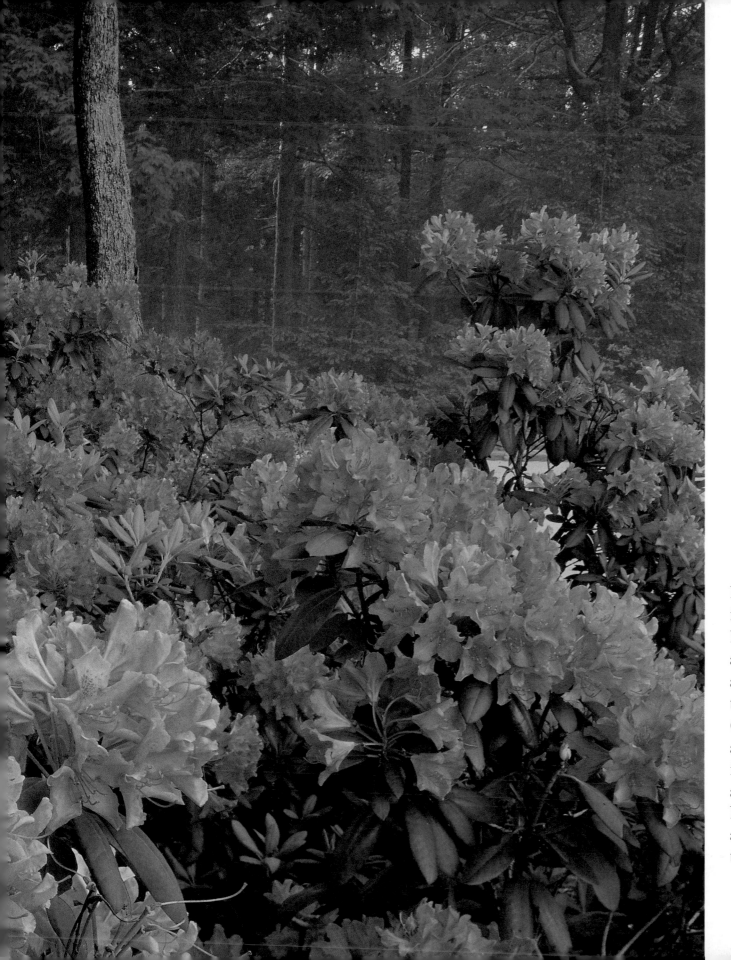

Rhododendrons flourish in Leonard Harris State Park, another preserve along the banks of the Pine Creek Gorge. The area above the gorge is a favorite with anglers and hunters, while kayakers, canoeists, and rafters explore the waters below.

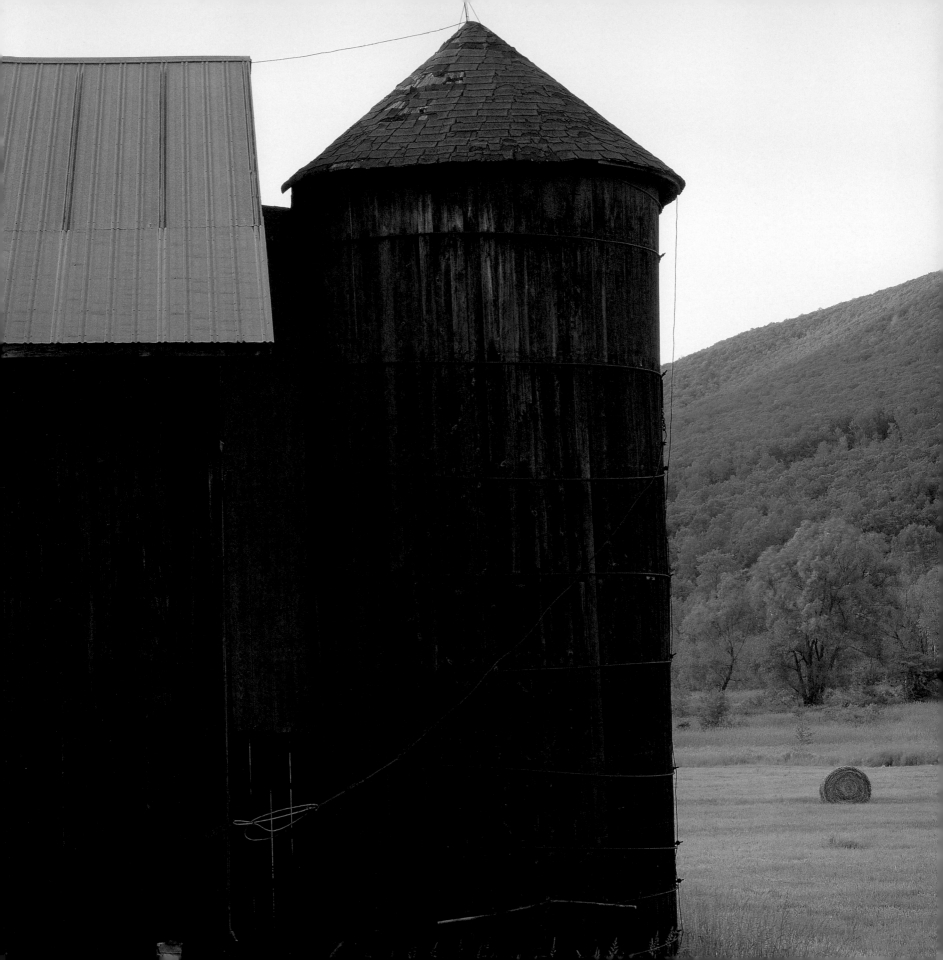

Lycoming is Pennsylvania's largest county, encompassing parks, forests, and fertile farmland. Homesteaders first followed the Susquehanna River to the area in the 1700s.

A silo and barn stand silent and still in the early morning light in Tioga County. Following Pine Creek from the northern forests to the Susquehanna River, native trading routes passed through this region for thousands of years.

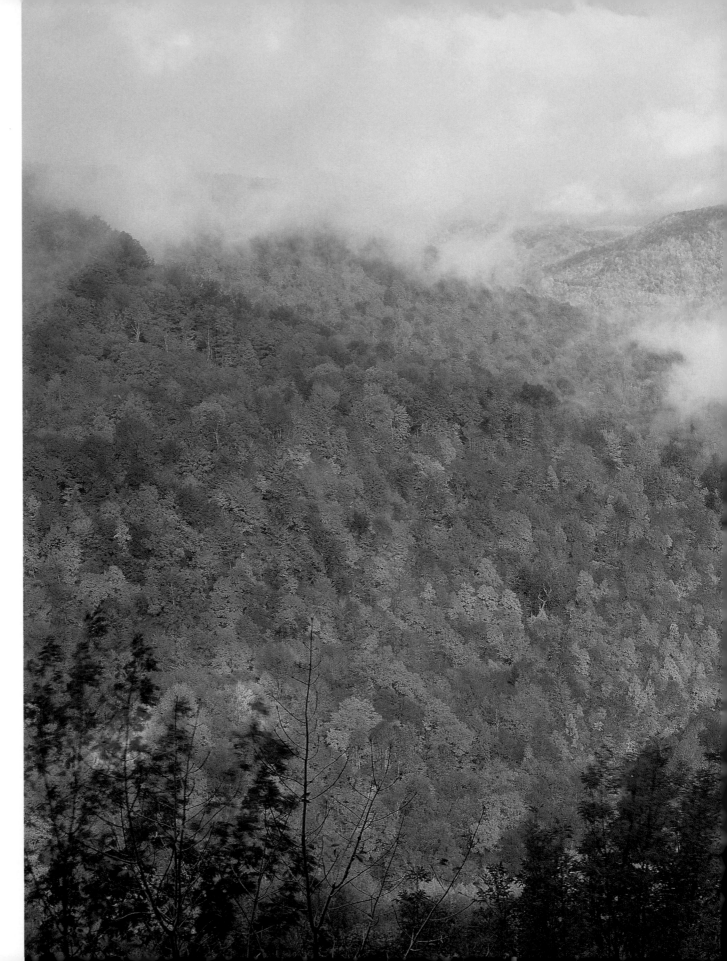

As early settlers made their way across the Endless Mountains, steep precipices, converging mountain ranges, and boiling rivers and whirlpools convinced them they were nearing the end of the world. Worlds End State Park protects some of the most rugged territory in the area.

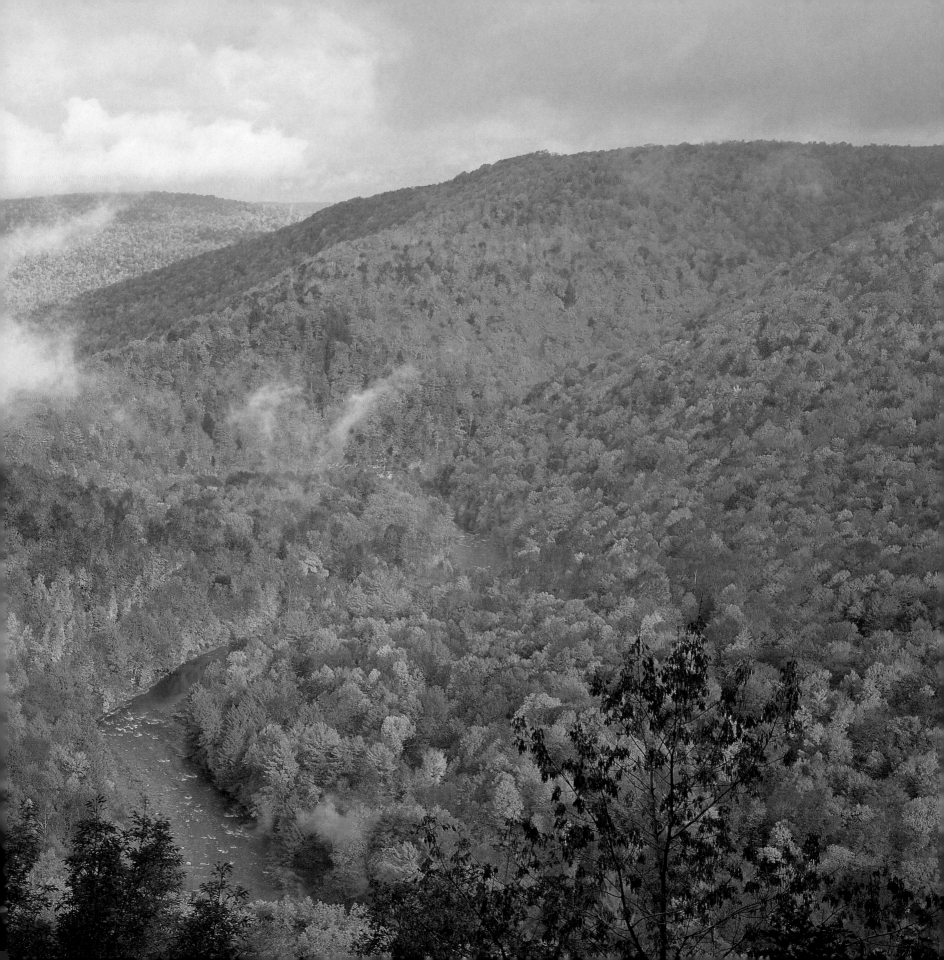

Worlds End State Park is at its most spectacular in June, when the mountain laurel blooms, and in fall, when the hardwood trees turn vivid shades of orange and red.

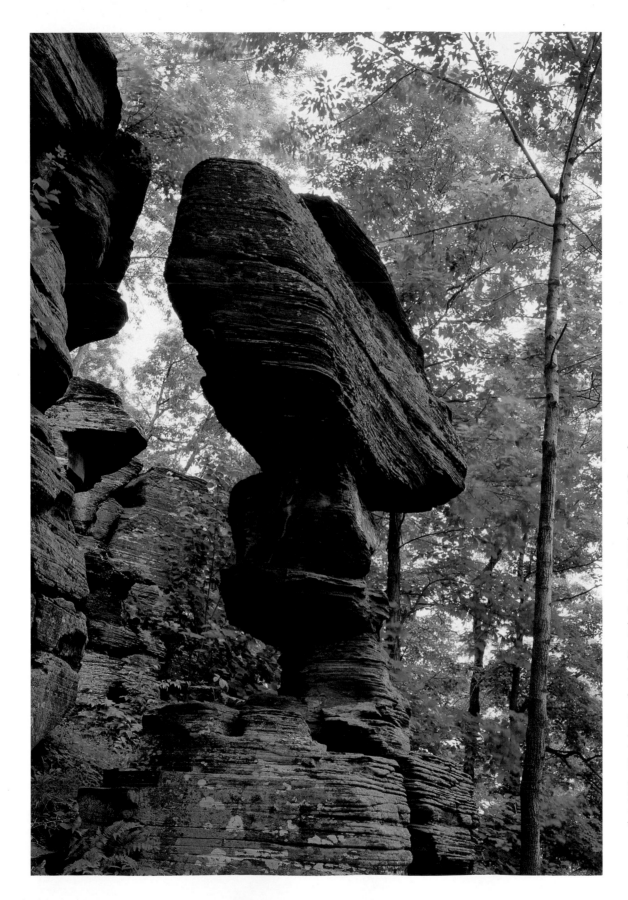

The pristine forests of northeastern Pennsylvania have a bloodstained past. In the 1700s, Connecticut and Pennsylvania fought over these lands, both establishing settlements here. But a third group with older claims to the land—the Lenni Lenape—attacked the communities, prompting the Pennamite-Yankee Wars.

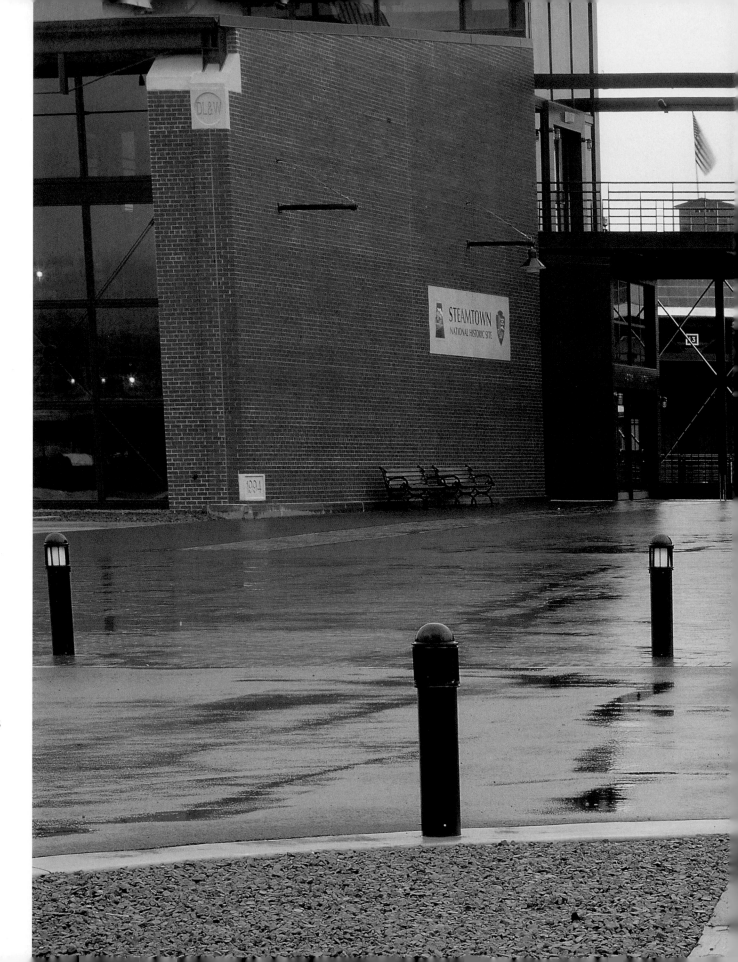

Created in 1986 to preserve and interpret the history of Pennsylvania's railways, Steamtown National Historic Site allows sightseers a close-up look at operating steam locomotives, as well as historic buildings from as far back as 1865.

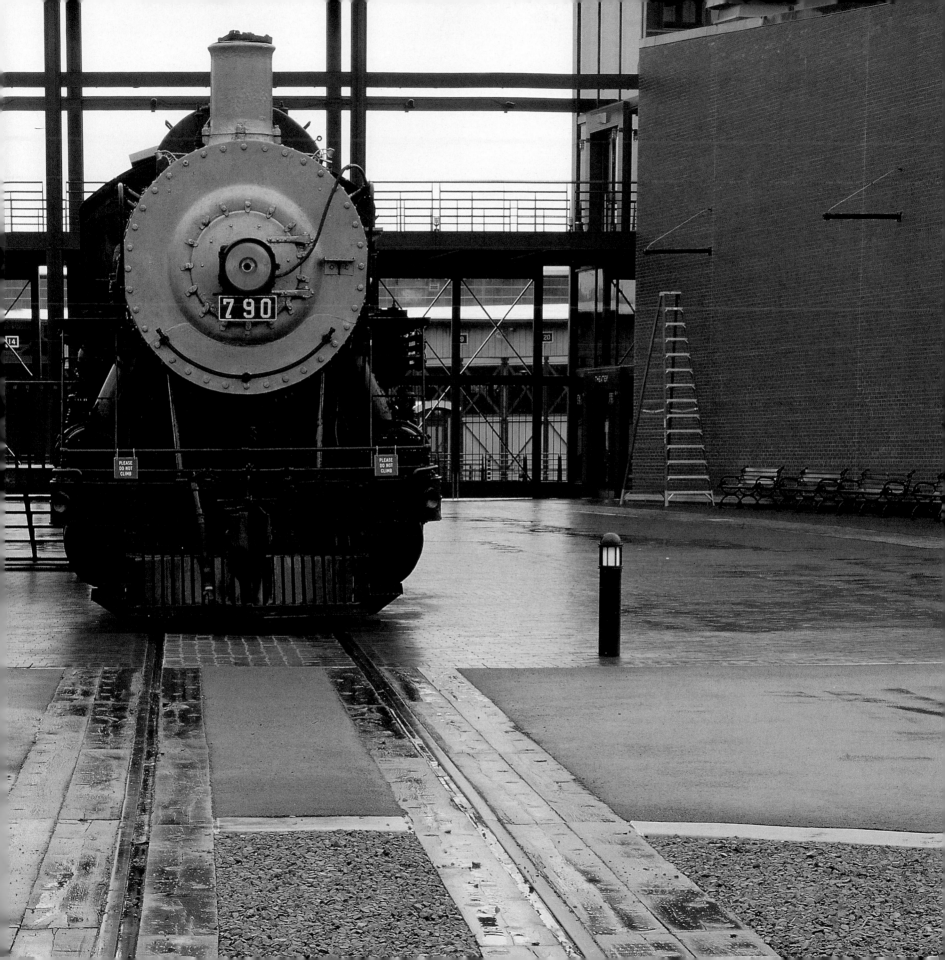

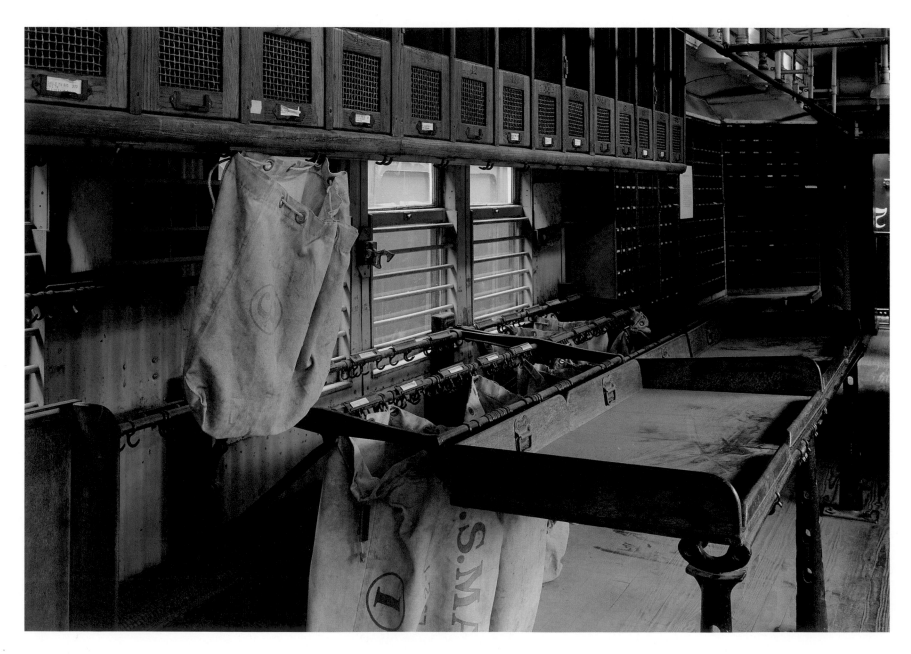

This railway post-office car at Steamtown National Historic Site was one of thousands that delivered to towns along the rail lines for more than a century. The last post-office car operated in 1977.

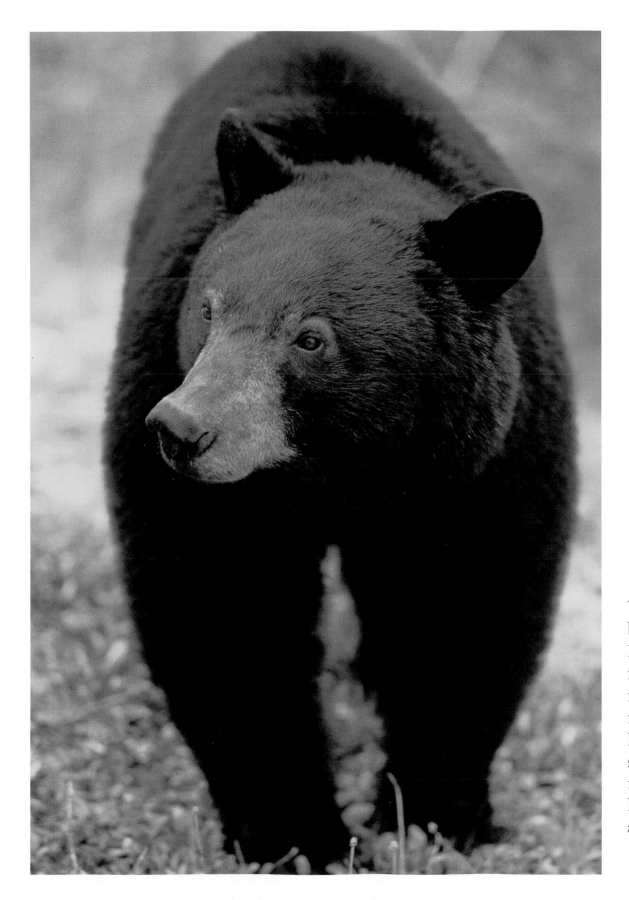

The omnivorous black bear roams Pennsylvania's forests in search of berries, insects, and small mammals. Some hunt territories as small as 10 square miles; others wander hundreds of miles in a single season.

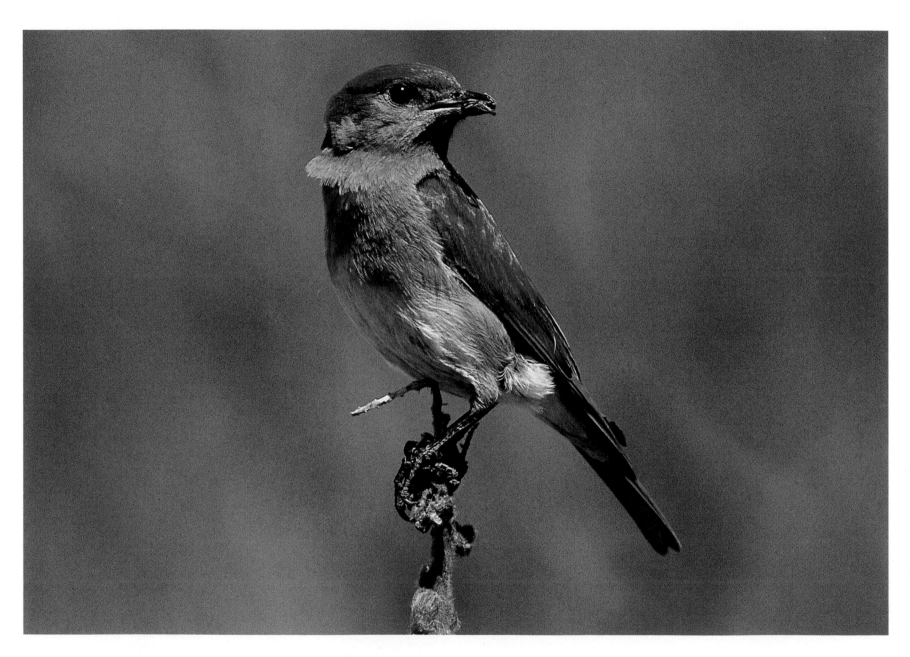

A mountain bluebird is occasionally spotted in the fall and winter months. In spring, they return to their breeding grounds in the west.

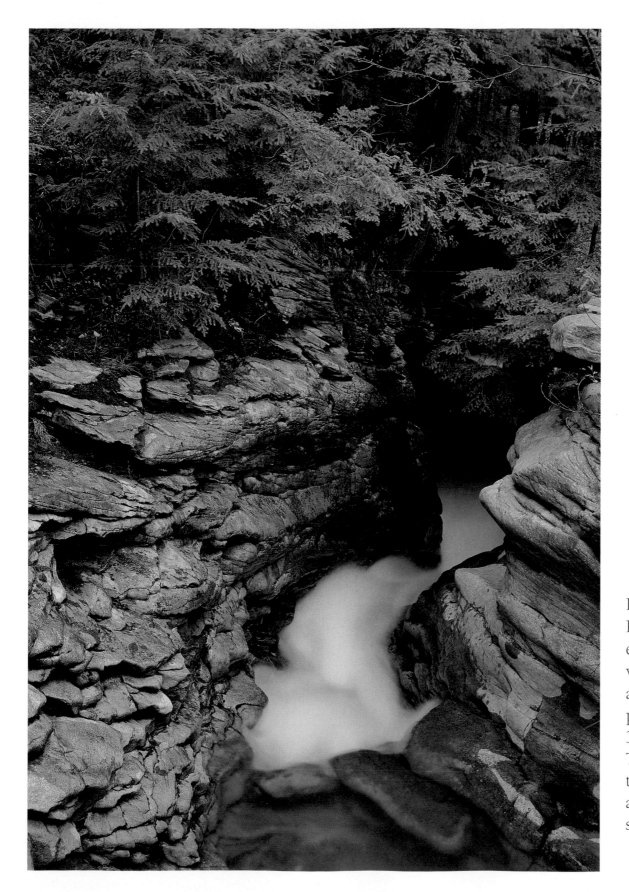

Eight state parks in
Pennsylvania's north-
east corner, along
with regional parks
and nature areas,
protect more than
35,000 acres of land.
The region is home
to black bears, deer,
and abundant bird
species.

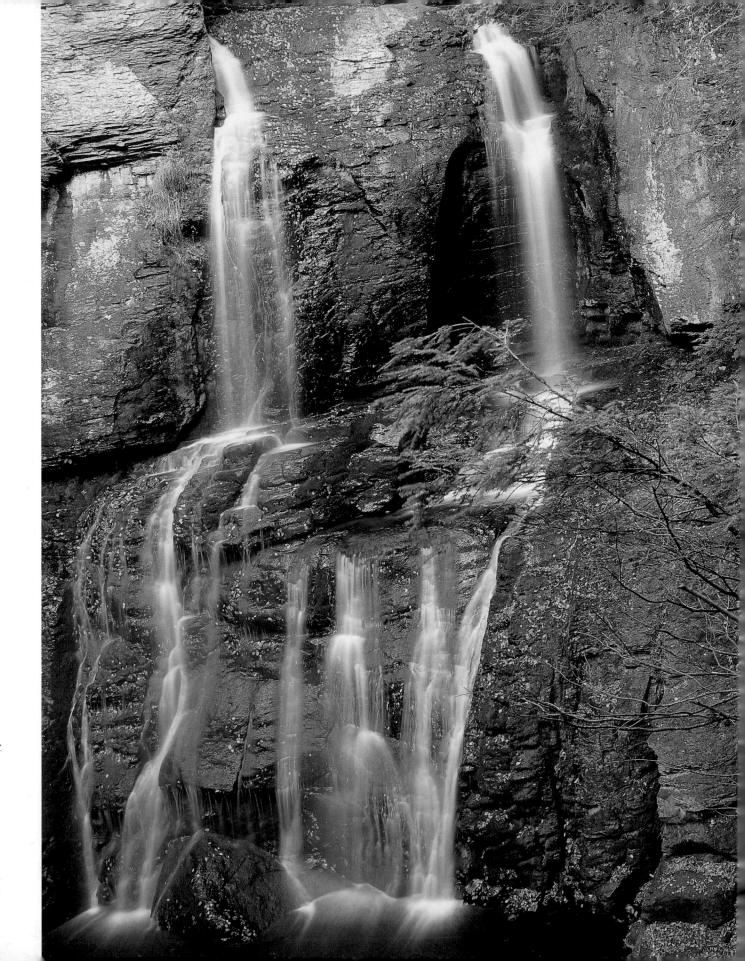

Half way between
Philadelphia and
New York City, the
Pocono Mountains
feature dramatic
waterfalls, vibrant
foliage, and pristine
fishing pools. In
winter, more than
a dozen ski resorts
draw visitors to
the region.

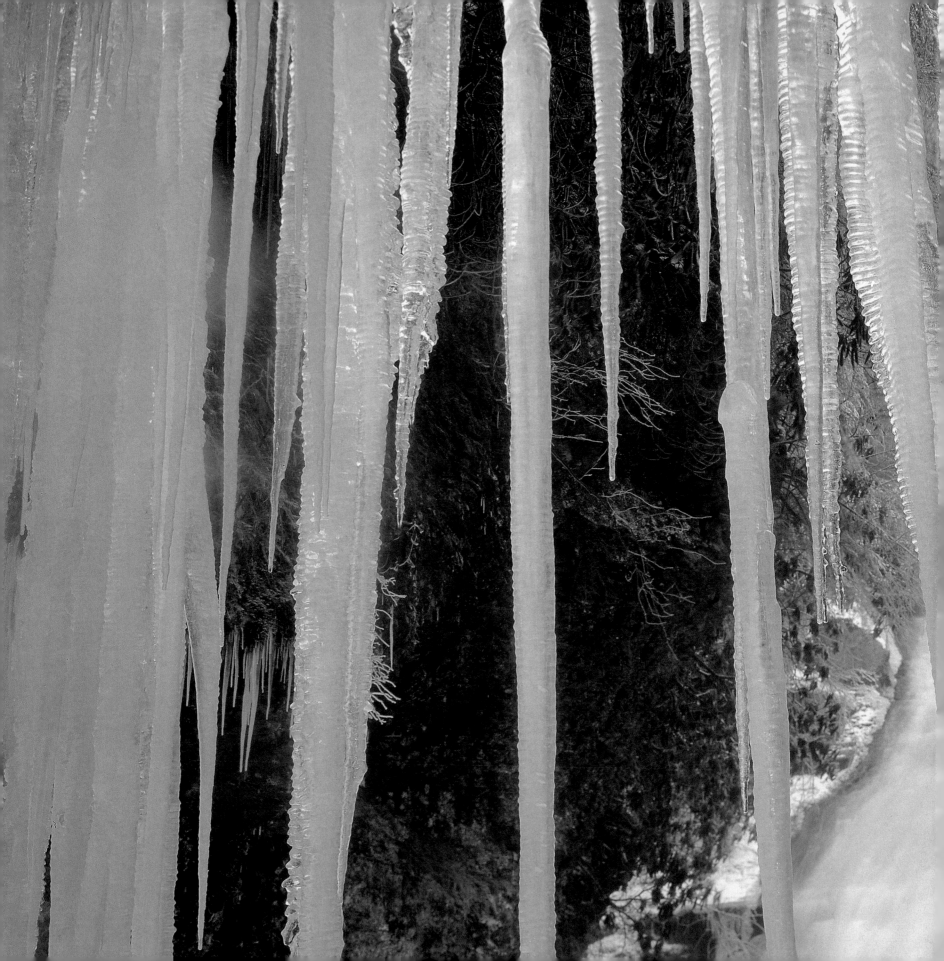

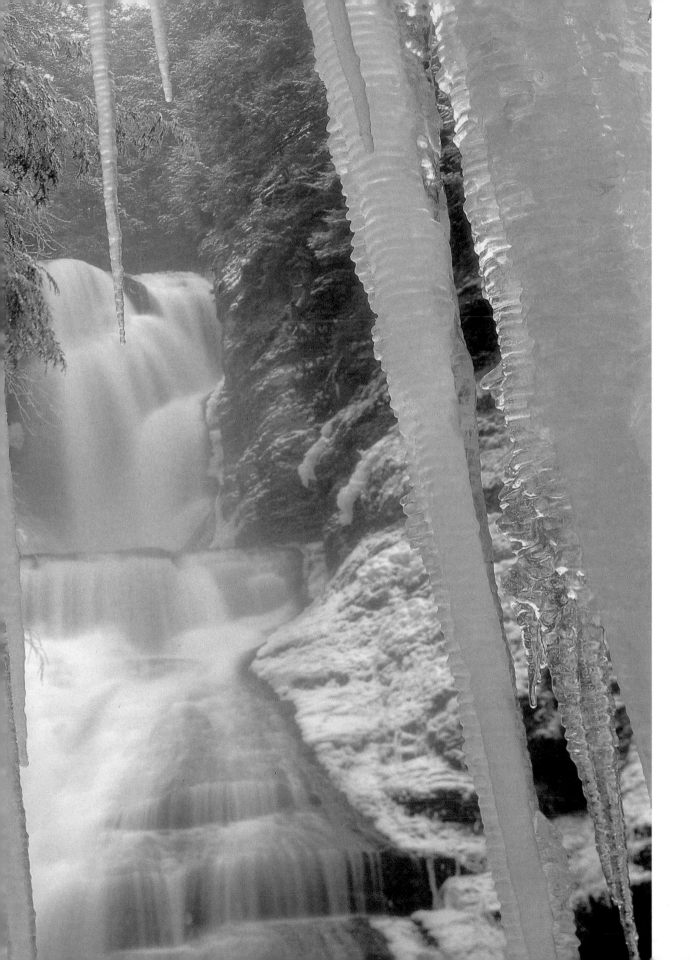

The Delaware Water Gap National Recreation Area protects the banks of the Delaware River, the border between Pennsylvania and New Jersey. The gap itself is a ravine that was slowly carved through the mountain ridge by the river.

95

Photo Credits